Monet

Artists in Focus

Monet

Andrew Forge

THE ART INSTITUTE OF CHICAGO

Produced by the Publications Department of The Art Institute of Chicago, Susan F. Rossen, Executive Director
Edited by Susan F. Rossen and Britt Salvesen in consultation with Charles F. Stuckey
Production supervised by Katherine Houck Fredrickson and Manine Rosa Golden

Photography, unless otherwise noted, by the Department of Imaging and Technical Services, Alan B. Newman, Executive Director

Figs. 4, 8, and 13: All rights reserved, The Metropolitan Museum of Art, New York. Fig. 15: Courtesy the Trustees of the National Gallery, London. Fig 17: All rights reserved, Document Archives Durand-Ruel, Paris.

Cover: Claude Monet, *On the Bank of the Seine, Bennecourt (The River)*, 1868 (detail of pl. 3)
Details: p. 15 (see pl. 3), p. 19 (see pl. 4), p. 27 (see pl. 6), p. 33 (see pl. 8), p. 41 (see pl. 13), p. 47 (see pl. 17), p. 59 (see pl. 27), p. 63 (see pl. 31), p. 71 (see pl. 7)

Designed by Joan Sommers Design, Chicago
Typeset by Paul Baker Typography, Inc., Chicago
Color separations by Cooperativa Lavoratori Grafici A.R.L., Verona, Italy
Printed and bound by CS Graphics, Singapore
Distributed by Harry N. Abrams, Inc., 100 Fifth Avenue, New York, NY 10011

Library of Congress Cataloging-in-Publication Data

Art Institute of Chicago.
 Monet / Andrew Forge.
 p. cm. — (*Artists in Focus*)
 Includes bibliographical references.
 ISBN 0-8109-4290-9
 1. Monet, Claude. 1840–1926—Catalogs. 2. Paintings—Illinois—Chicago—Catalogs. 3. Art Institute of Chicago—Catalogs. I. Monet, Claude. 1840–1926. II. Forge, Andrew. III Title. IV. Series: *Artists in Focus*.
ND553.M7A4 1995a 95–10039
 CIP

Contents

Foreword

This book features The Art Institute of Chicago's outstanding collection of works by Claude Monet. A century ago, a prominent and farsighted Chicago couple, Bertha Honoré and Potter Palmer, played an important role in stimulating Americans to collect the art of this early modern French painter and in helping establish his reputation in the United States. By the mid-1890s, the Palmers owned dozens of canvases by Monet and soon were selling them, at increasingly escalated prices, to acquaintances and dealers up and down the East Coast. A number of the works by Monet in the Art Institute—totaling thirty-four paintings and eleven drawings—are among the many now in museums across the country that can be traced back to the early support of the Palmers and their friends. In the case of the Art Institute, several paintings entered the museum in 1922, after the death of Mrs. Palmer; others came to us later, through the benefactions of her children, grandchildren, and

other Chicago collectors who were influenced by her.

Visionary though they were, the Palmers could never have imagined that their pioneering support of Monet would eventually result in one of the most important public collections of late nineteenth-century French art in North America, with extensive representations of the work of such artists as Cézanne, Degas, Gauguin, Manet, Redon, and Renoir, as well as such signal paintings in the history of this period as Seurat's *Sunday on La Grande Jatte—1884* and Caillebotte's *Paris Street; Rainy Day*. Some of these artists have been the focus of books published in conjunction with exhibitions organized by the Art Institute over the last decade. It seemed fitting to bring out this monograph on Monet in time for the opening of another such effort, the largest retrospective of this great French Impressionist ever organized in North America, an enormously ambitious undertaking that would not have been possible without the strengths of our permanent collections.

This book inaugurates a series, *Artists in Focus*, featuring individual treatments of key nineteenth- and twentieth-century figures who are represented in depth in the Art Institute's collections, such as Renoir, Picasso, Matisse, and Cornell. In *Monet*, we are pleased to publish an appreciation of this artist and the Art Institute's collection of his work by Andrew Forge, professor emeritus of art at Yale University. A well-known author of a number of books on Monet, as well as on other artists, such as Chaim Soutine, Giorgio Morandi, and Helen Frankenthaler, Forge is first and foremost a painter, as his deeply felt and eloquent text makes clear. Approaching the art of Monet as an artist himself, he helps us see the artist and his work anew. We are very grateful to him.

James N. Wood, Director and President
The Art Institute of Chicago

When Claude Monet was a schoolboy in Le Havre, he developed a talent for caricature (see figs. 1–3). It was probably a useful vehicle for his independent energy—one can deduce something of his attitude toward authority from the image he made of an official in a local arts society (fig. 3). As Monet later attested, he drew his caricatures "everywhere and anywhere—at the theater, in cafés, at the homes I visited." He was able to display his drawings in the window of a frame-maker's shop; and, to his great delight, they attracted an audience.

Monet was interviewed many times in the fame of his old age, and always his account of how he became a painter would start at the frame-maker's shop. He told it as an epiphany, almost a religious conversion. The shop had once belonged to the landscape painter Eugène Boudin, a native of Le Havre, who also showed his work there. Monet, adolescent and full of prejudice, thought nothing of Boudin's paintings. Boudin, who was fifteen years older than Monet, introduced himself and invited the beginner to come and work with him in the open air. Monet demurred, then finally agreed. While he was watching Boudin at work, something happened: "I was overcome by deep emotion. . . . More, I was enlightened. Boudin truly initiated me. From that moment on, my way was clear, my destiny decreed. I would become a painter, come what may."

This must have happened when Monet was in his mid-teens. His father wanted him to enter the family grocery and ship-supply business. His mother was more sympathetic, but she died when he was seventeen. Her place in the family was taken by his aunt, Marie Jeanne Lecadre. An amateur painter herself, she was not opposed to his friendship with Boudin and had contacts with painters in Paris. Monet's caricatures must

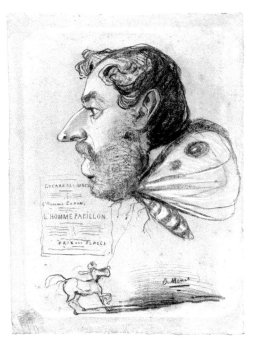

1. Claude Monet (French; 1840–1926). *Caricature of Jules Didier,* probably 1860. Charcoal, heightened with white chalk, on blue laid paper, 61.6 x 43.6 cm. The Art Institute of Chicago, Gift of Carter H. Harrison, 1933.889. All figures and plates illustrate works by Claude Monet in The Art Institute of Chicago, unless otherwise noted.

have earned him something of a reputation among the citizens of Le Havre, for he made brisk sales, banking his earnings with his aunt. When the time came to confront his father's opposition to his becoming a painter, he had saved two thousand francs. Armed with this and several letters of introduction, he set off for Paris.

Monet's caricatures themselves are anything but engaging as drawings. He was rehearsing with a certain brash skill an idiom that was commonplace in the newspapers of the time. What is interesting is to consider the bearing that the impulse toward caricature might have on his later work. Caricature depends on two processes: exaggeration and condensation, on a kind of distortion that renders likeness with the force of an epigram. Not all artists are capable of this. We can see something of the caricatural impulse at work in the witty shorthand with which Monet made the fishermen on the left of *The Beach at*

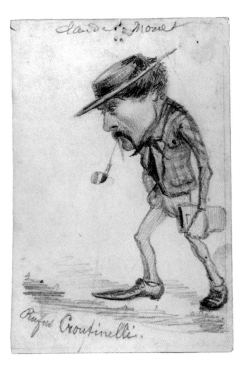

2. *Caricature of Henri Cassinelli: "Rufus Croutinelli,"* probably 1858. Graphite on tan wove paper, laid down on tan wove card, 13 x 8.4 cm. Gift of Carter H. Harrison, 1933.893.

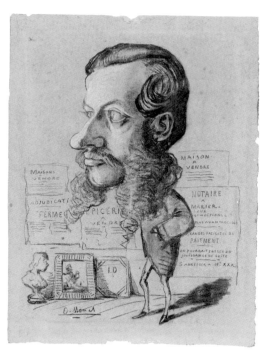

3. *Caricature of Léon Machon,* probably 1858. Charcoal, with stumping, heightened with white chalk, on blue laid paper, 61.2 x 45.2 cm. Gift of Carter H. Harrison, 1933.888.

Sainte-Adresse (pl. 2), or the distant passengers in *Arrival of the Normandy Train* (pl. 5). But, at a deeper level, it could be argued that the way he came to reduce his subject to effects of light, translating every feature into discrete strokes of color, summons up the same principles of exaggeration and condensation, now positively redeployed.

Sainte-Adresse

Just outside Le Havre, in the fishing village of Sainte-Adresse, the Lecadre family had a villa where Monet reluctantly spent the summer of 1867 (see fig. 4). By now his career was launched. He had done military service in North Africa

with the *chasseurs*, had been sent home on sick leave, and had been bought out of the service by his family on condition that he study art in one of the recognized studios in Paris. This had brought him to the atelier of Charles Gleyre, where he made his first close friends—Frédéric Bazille, Pierre Auguste Renoir, and Alfred Sisley—independent painters who, like him, were more interested in the adventure of painting out of doors than in learning the studio conventions. Monet had formed an alliance with a young woman, Camille Doncieux, who was now expecting a baby. (They would marry in 1870.) The family had withdrawn Monet's small allowance in the hope of persuading him to leave her. He spent a tense and unhappy summer with his family, managing to borrow money that he sent to Doncieux in Paris. But it was a productive season, for he worked on the beach and prepared some large canvases for the next year's Salon, the official art exhibition held annually in Paris.

The black chalk drawing *Cliffs and Sea* (pl. 1) is witness to hours Monet spent on the beach, the location of his principal subjects at this time. It is one of a series of four in which, anticipating his later obsession with the movement of light, he tracked the passage of sunlight across a cliff. A drawing made as an end in itself is fairly rare in Monet's work; for him the activity had none of

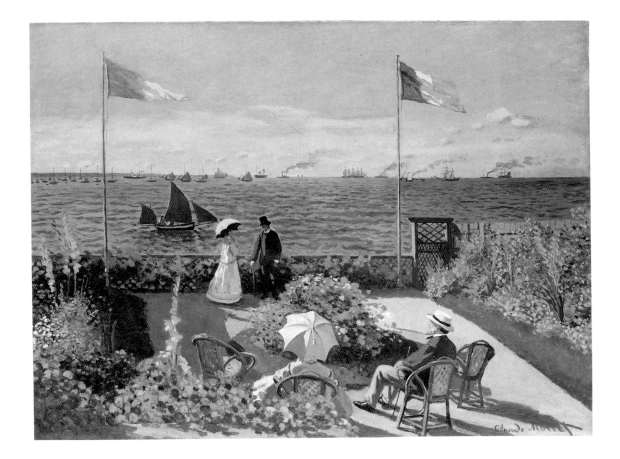

4. *Garden at Sainte-Adresse*, 1867. Oil on canvas, 98.1 x 129.9 cm. The Metropolitan Museum of Art, New York, Purchase, special contributions and funds given or bequeathed by friends of the Museum, 1967.

the importance that it had for Edgar Degas or Camille Pissarro. As he became better known, he was often asked to draw copies of his paintings for reproduction in magazines. In these he attempted, as he did here, to reconstruct effects of light and texture with forceful and elaborate hatching. But the majority of his drawings are quite different in style and intention. They are compositional studies done in outline only. "I have never liked to isolate drawing from color," he told an interviewer at the end of his life.

He was still hoping to make his name through the orthodox channels and had already had some success. Two seascapes had been well received at the Salon of 1865. The conservative critic Paul Manz had commended his "audacious way of seeing things." The following year, he had shown a full-length portrait of Doncieux in a green dress (fig. 5), which had attracted a great deal of attention. Conservative critics gave grudging praise, always questioning his lack of "finish," but the younger critics, Emile Zola in

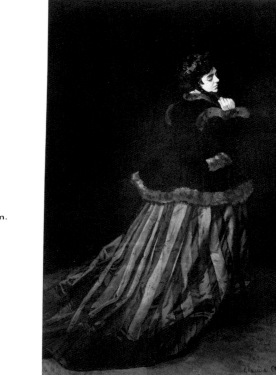

5. *Camille in a Green Dress*, 1866. Oil on canvas, 228 x 148.9 cm. Kunsthalle Bremen.

particular, were enthusiastic. Monet, Zola wrote, was "a man among this crowd of eunuchs." He was more than a Realist; he was an interpreter who was as delicate as he was strong.

Of the two large paintings that he worked on for the Salon during the summer at Sainte-Adresse, only one was accepted. Called *Ships Leaving the Harbor*, it is now lost. Our only knowledge of the composition comes from caricatures of it in the popular press. These represent it in a pseudo-childish style; the caption to one of them declares: "Here at last is an art that is truly naïve and sincere. M. Monet was four and a half when he made this picture." The caption plays with terms that were current in discussion of the values of artists who were working from nature, the "exponents of naïveté and spontaneity," as one authority called them. These qualities were opposed to the academic tradition according to which a sophisticated knowledge of the painting of the past, a skillful application of "rules" of composition, and a meticulous, painstaking finish governed the final product. According to modern Realist doctrine, it was nature, not the museum, that was the source of authentic art. The modern painter had to focus on what he saw in the world and, to meet this obligation, to purge himself of all preconceptions. The painter Camille Corot, Monet's great forerunner, was to advise the young artist to address nature "with naïveté and according to your personal feeling, disassociating yourself entirely from what you know of the old masters." Monet wrote to Bazille, "The farther I go, the more I regret even the small amount of knowledge that I have."

It takes an effort of the imagination to recapture the shock that this willed artlessness must once have produced. Before *The Beach at Sainte-Adresse* (pl. 2), we are more likely to react to the astonishing precision with which Monet translated light into color and to the way that he

sustained this silvery seaside light across every inch of the picture's surface. This kind of unity is the consequence of intense observation and a profound understanding of the palette. His hand followed his eye, moving staccato across the pebbles of the beach, flat and sweeping over the calm sea, and emphatic in the gleaming clouds, the source of the high, shadowless illumination. The picture is as much about the painter's looking as it is about a place. And as if to assert and quietly celebrate the act of looking, the two figures at the water's edge are themselves absorbed in scanning the horizon through a telescope. This theme—the observer within the picture—appears repeatedly, both in Monet's work at this time and in that of his like-minded contemporaries, as though to draw attention to how the stories of traditional art, with their manifold cultural references, had been replaced by a single, infinitely various story, the story of the eye, the story that is embedded in the fabric of the picture itself.

On the Bank of the Seine, Bennecourt (The River), 1868

The river Seine was a constant presence in Monet's life. Place names along its winding course between Paris and Le Havre evoke a catalogue of his work: Argenteuil, Vétheuil, Giverny, Vernon, Rouen. The moves he made from place to place are important in a way that they would not be to another kind of painter. For him, his subjects were his surroundings. His art is founded on the first-hand.

During the spring of 1868, Monet took Camille Doncieux and their baby, Jean, to lodgings in the village of Gloton, near Bennecourt. The reception of his paintings in the Salon had been disappointing, and, although his reputation was rising fast among his younger colleagues, he was still living from hand to mouth. He was relying on his friends, particularly on Bazille, who had private means. The family was not long at Gloton. Quite soon Monet ran out of funds, and the couple and baby were evicted from their lodgings. Monet wrote despairing letters to his friends. Help came from an industrialist in Le Havre named Gaudibert, who commissioned portraits of his family. Later in the year, Monet showed some sea paintings at a maritime exhibition at Le Havre and was awarded a silver medal. This was a moral triumph only, as his canvases were seized by creditors. He was finally able to sell the famous portrait of Doncieux, his triumph at the Salon of 1866; and by the end of the year, thanks to Gaudibert's patronage, he was settled with his family in lodgings on the coast, and he was contentedly at work.

One would hardly guess at these travails, looking at *On the Bank of the Seine, Bennecourt*

The far bank and the river fill the woman's field of vision. The surface of the water is unruffled. The reflections are intact. What she sees, and what we see with her, is a world of reflections, a watery, upside-down world of pure visibility that only exists in the eye and under these conditions.

(pl. 3). It has an air of calm and luminous optimism, a radiance that makes it understandably one of the most loved of all his paintings. It is a canonical image in the history of early Impressionism. The arrangement is traditional, with the trees and riverbank framing the distant view. Doncieux is half turned away from us. Her pose is still, absorbed, and completely matter-of-fact: she is simply sitting there, enjoying the view. It is the strongest version Monet ever did of the observer theme. The far bank and the river fill her field of vision. The surface of the water is unruffled. The reflections are intact. What she sees, and what we see with her, is a world of reflections, a watery, upside-down world of pure visibility that only exists in the eye and under these conditions. The big house whose reflection faces her is itself almost invisible to us between the leaves of the tree. She can see it. The sky at her feet leaps the riverbank to join with the cobalt ribbon of her hat.

The surface structure of *The River* (as the painting is sometimes called) is that of a sketch. It is built on the kind of economic selection that the sketcher's eye insists upon. But there is nothing loose or approximate in Monet's notations. Everything within the frame of the picture is seen first as a patch of color against another patch of color. Each interval is exactly and precisely judged. Hitherto this reduction would have been simply a step on the way toward a construct that involved memory, knowledge, drawing, naming—in short, a picture. The attacks that Monet's conservative critics leveled against his lack of finish are understandable. What they could not recognize was that an entirely new conception of completeness was being built out of the sketcher's rough and reductive marks. Painting had never before found a place for this tonality, this cool sparkling light, this vibration, this transparency, this anchorage in the immediate present of the sense of sight.

Hitherto artists had used sketches to record observations, to try things out, to develop ideas. Sketches were private rehearsals. One of the most fascinating aspects of *The River* is the way it hangs somewhere between the private and the public. It is a firm pictorial statement, fully intended. On the other hand, Monet did not attempt to conceal how he changed his mind as he worked toward this statement. At one point, Jean was here in his mother's lap, then rather crudely painted out with little effort made to tidy up his traces or redraw the profile of her skirt. The mass of foliage immediately over her head is clearly a later addition over half-dried paint. It has often been noted that the reflection in the water of the sky, with its bands of clouds, does not correspond to the clear blue overhead. This might be interpreted as a compositional feature

added on purpose, but this would be to miss the point that it represents an earlier moment. Time, weather moved on, and so did he. Monet had what he wanted on the canvas, and there was no compelling reason to correct it. Later in his life, he was to pay fanatical attention to consistency. Meanwhile, as we follow the quickly brushed notes of deep blue and how he used them to carve the sides of the boat, to assert the gap between Doncieux's back and the tree, to touch the ribbon on her hat and the tiny figure on the far bank, we are following the processes of his hand and eye. The making of the picture is as open to us as what it manifestly represents.

The Artist's House at Argenteuil, 1873

In July 1870, two years after Monet painted *On the Bank of the Seine, Bennecourt,* war broke out between France and Prussia. The French armies were swiftly defeated, and the Second Empire collapsed. The Prussians laid siege to Paris, bombarding it with heavy guns. Several of Monet's friends were drawn into these events. Bazille was killed in the early days of the war, and both Degas and Edouard Manet defended the capital during the siege. An armistice was signed in January 1871. Shortly after the withdrawal of Prussian troops, the workers of Paris rose against the provisional government, which fled to Versailles. Now ruled by the leftist Commune,

Paris underwent a second siege. This lasted until May and ended in a bloodbath in which as many as thirty thousand Communards were executed and many more exiled. The artist Gustave Courbet was imprisoned for his part in the Commune. The city that thought of itself as the very center of civilization was humiliated by defeat and riven with class hatred and guilt.

Having no desire to be drawn into these events, Monet had made his way to London as soon as the war started. He returned via Holland, arriving in Paris late in the summer of 1871. A few months later, he rented a house at Argenteuil, a few miles downriver from Paris, where he was to live and work for the next seven years.

Before the war, Monet's ambition had been to achieve a career in traditional fashion—on the walls of the Salon—but as an uncompromising Realist in the mold of Courbet and Manet. He expected the battle to be hard-fought. This was the dilemma facing all the independent painters of Monet's generation: how to pursue their radical vision and, at the same time, gain public acceptance. He was one of the first to realize that the way ahead lay not through the established channels but with dealers and individual shows.

Monet's submissions to the Salon during the 1860s were large compositions depicting aspects of modern life. They were painted—or planned —on an ambitious public scale. Unlike the com-

Camille and Jean Monet are the principals in an idyll of suburban security. Here Jean is framed by flowers and guarded by orderly planters, the firm facade of the house, his mother at the door. Above, blue sky, puffy clouds rise like a song.

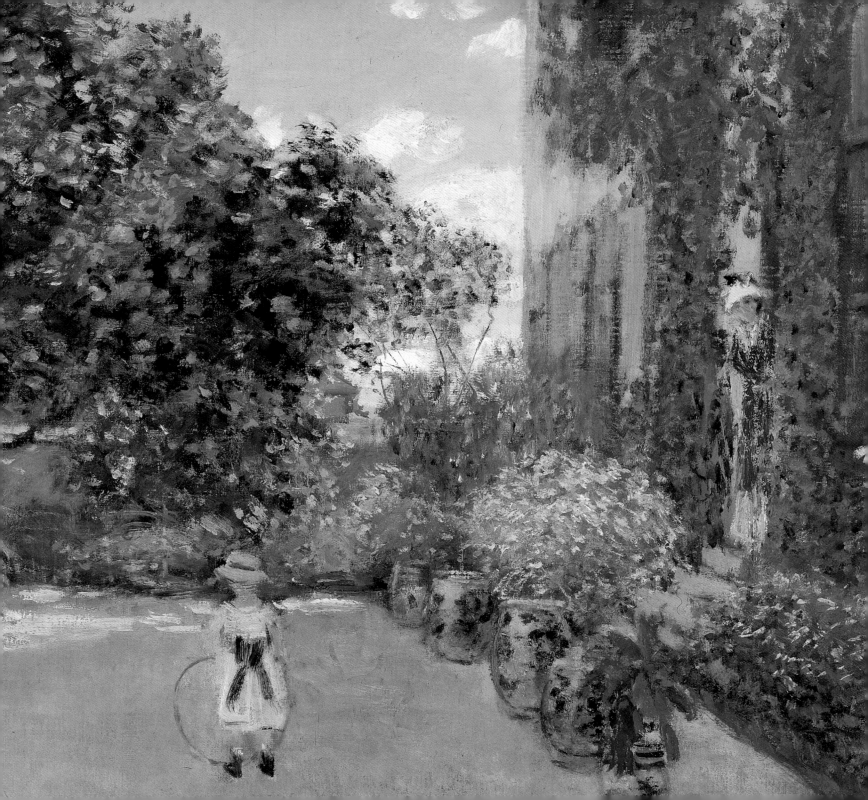

positions that dominated the Salon, they offered no narrative content, no make-believe. They were of his friends picnicking in the forest, or of Doncieux showing off the latest fashions in a garden, or of bathers and boaters splashing around in the Seine. Nor were they "finished" in an accepted way; rather, they preserved, even on their large scale, the raw attack and abrupt reductions of the sketch. In all these pictures, the essential subject was the figure in context, the interaction of people with place and real light. It was with the eye of a city dweller, conscious of the moment, that Monet understood this interaction. The Realist novelist Zola, one of the artist's earliest supporters, recognized exactly what the painter was trying to do: "He is pleased to discover man's trace everywhere," he wrote in 1868. "As a true Parisian, he brings Paris to the country; he cannot paint a landscape without including well-dressed men and women. Nature seems to lose its interest for him as soon as it does not bear the stamp of our customs."

By the time Monet re-entered the fray after his return from London, he had moved far from his old goal of fame through the Salon. In the postwar atmosphere, radical art was even more distrusted by the establishment. One of the contacts the artist had made in London was with the Parisian dealer Paul Durand-Ruel, who had become interested in Monet's work and had

begun to buy it. From now on, Monet's fortunes would be bound up with private galleries and independent exhibitions. He would rarely paint on a large scale until, toward the end of his life, he embarked on the great decorative compositions of water lilies.

For a while, thanks to Durand-Ruel's purchases, Monet was able to enjoy a degree of comfort. Although he was always short of ready cash, it seems that during his residency at Argenteuil his sales averaged fourteen thousand francs a year, a solid professional income. The whole French nation was in the throes of rapid economic development, in transition from an agrarian to an industrial society. Argenteuil, only a few years earlier a quiet country town, was now only fifteen minutes from Paris by rail. It was a place where Parisians were buying land, weekend cottages, and country houses. Crowds came there to enjoy yachting on the river or idle walks on the riverbank. At the same time, industry and its attendant pollution were spreading. All this has been wonderfully described by Paul Hayes Tucker, who has shown in detail how this town, at this particular moment, gave Monet the subjects that he needed. "Progress" was manifest here— in the interaction of city and country, in the delights of nature shaped by civilization, in the celebration of bourgeois freedom.

The 170 or so paintings that Monet made at

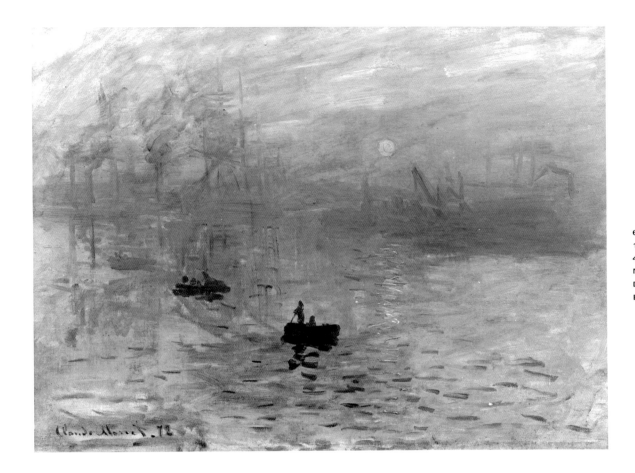

6. *Impression, Sunrise*,
1872. Oil on canvas,
48 x 63 cm. Musée
Marmottan, Paris,
Donop de Monchy
Bequest, 1957.

Argenteuil, one of which is *The Artist's House* (pl. 4), are among his most-loved works. In them Impressionism (the name comes from a painting that Monet showed in 1874 [fig. 6], in the first group show of independent artists) came confidently into its own. A new kind of beauty is found, an accord through which the whole field of the painting exists on equal terms. No part has precedence. There are no hierarchies—of focus, of form over background, or of light over shadow. All this speaks, with a certain detachment, from the eye to the eye. If emphasis is withheld from local incident, it is reinvested in the whole, in light seen not as a contrast of light against non-light but as an engagement of color—yellow to blue, orange to violet—without either highlights or gradations.

Some commentators have wondered how these joyful paintings could have been made in the shadow of the terrible events of 1871. Did Monet's detached way of looking at things mean that he was indifferent to human affairs? The

affirmative tenor of his work is surely too insistent to be dismissed as accident; his celebration of immediate experience is optimistic, making reparation in the only terms that he knew. The house that Monet lived in at Argenteuil was in the middle of town, a few minutes' walk from the railway station and not much farther from the river. Here he was able to exercise his love for gardening and, in a sequence of paintings, his wife and son are the principals in an idyll of suburban security, dreaming among well-tended beds and light-dappled paths. In the Chicago picture, Jean is framed by flowers and guarded by orderly planters, the firm facade of the house, his mother at the door. Above, blue sky, puffy clouds rise like a song.

Arrival of the Normandy Train, Saint-Lazare Station, 1877

By 1876 it seems that the confrontation of town and country that had so fascinated Monet at Argenteuil had begun to lose its charm: "progress" was turning Argenteuil from a suburban playground into a center of industry. He could no longer sustain his vision of a suburban Cythera. Soon Zola's assumption that Monet was only interested in a city-dweller's landscape would lose its pertinence; the social observer, the painter of modern life, would give way to the painter of pure landscape.

But there was to be a last confrontation with the most evident of all the agents of change: the railway. In the winter of 1876–77, Monet applied to the authorities for permission to work in the Paris terminus of the railway that served the Seine valley, the Saint-Lazare Station. He rented a small studio nearby. In less than three months, he completed twelve canvases, including one now in the Art Institute (pl. 5), painting on the spot and probably reworking some of them in the studio. In the third Impressionist exhibition, which opened in April, Monet showed no fewer than thirty paintings, eight of which were of the station. The paint can hardly have been dry.

The railway played a large part in changing the countryside, inserting the artificial clock-time of its timetables into lives hitherto ruled by natural time. The train opened the provinces to the city. Saint-Lazare must have been loaded with memories for Monet. Both the highway bridge and the railway bridge over the Seine at Argenteuil had been wrecked during the war, and one of Monet's first subjects there had been of reconstruction (see fig. 7). Later he painted commuter trains puffing their way across the railway bridge; and, in one marvelous canvas, he showed an arrival at a snow-covered platform, the lights on the locomotive glowing red in the frosty mist, turning the banal event into a moment of delicate wonder.

Monet was at once a realist and an aesthete, robust and delicate, coarse and refined. These paradoxes run throughout his work. He could seem to be searching and questioning and analyzing what he saw, and at the same time to be projecting decorative harmonies that were subjective, his alone. The question that his work always raises is how these two drives—to take in and to give back—stand in relation to each other. It was of course his concern with light that held the balance between these two sides of his endeavor, light that played equally over all things, light that could be re-created as color. The implications of this were only half understood at first even by his most sympathetic critics. Georges Rivière, a friend of Renoir, wrote at some length about the Saint-Lazare paintings;

> One can see the enormous, maddening commotion of a station, its floors trembling with every turn of the wheels. The platforms are moist with soot and the atmosphere reeks with the acrid odor of burning coal.
>
> Looking at this magnificent picture, one is taken with the same emotion that nature would arouse.

In these few lines, Rivière invoked the sense of hearing ("commotion"), of touch ("trembling," "moist"), and of smell ("acrid odor"), but in the paintings themselves it is the sense of sight alone

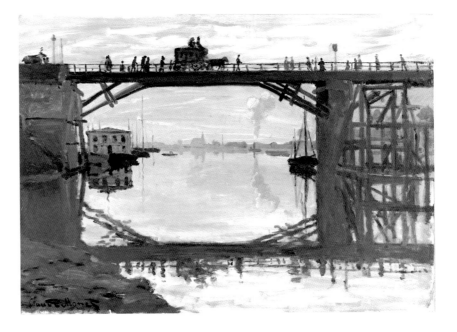

that is paramount. Indeed, sight drives out every other reaction. In the Chicago picture, far from being drawn into the jostling crowds, we see them only at the far end of the platform, faceless, gestureless, dark brush strokes among other dark vertical strokes that signify girders, lampposts, the stack of the locomotive. At the same time, Monet augmented those very conditions that we would not see if we were in fact caught up in the anxious commotion of the station: the filtered light from the roof that falls on the platform, turning the foreground into a field of lemony gray; the contrast between the light in the station and the white glare beyond; the way the smoke looks dark against the sky and rosy white as it drifts up into the roof; and the manner in which

7. *The Highway Bridge under Repair, Argenteuil*, 1872. Oil on canvas, 54 x 73 cm. Fondation Rau pour le Tiers-Monde, Zurich. Photo: Peter Schälchi, Zurich.

the strong, geometrical structures of the building are transformed and dissolved by momentary events, the plumes and puffs and gleams that turn the station, once we can see it in this way, into spectacle.

Still Life with Apples and Grapes, 1880

Above all a landscape painter, Monet did not often concern himself with the limited interior spaces of still life. Still lifes were, however, easier to sell than landscapes. He had painted several during the 1860s, very much in the eighteenth-century tradition of the still-life painter Jean Baptiste Chardin and responsive to what Courbet and Manet were doing with that tradition. They are sober in color and firmly drawn; the objects—fruit, china, dead game—are carefully arranged in frontal groups. Substance and texture and the way different surfaces take the light are brought out with a kind of opulent facility. Still life reappeared in Monet's work beginning in 1880, when he was under tremendous financial pressure. He was reconsidering his strategy, trying again to gain access to the Salon, and beginning negotiations with dealers other than Durand-Ruel. Several of the still lifes of this time found buyers at prices that were higher than those of his landscapes.

There was a second and more immediate reason for executing still lifes. They gave him something to do when the weather made it impossible to work out of doors. Later he was to defend his passion for gardening on the grounds that he needed flowers to paint if it was raining. But as time went on and he became more preoccupied with reworking his landscapes in the studio, still life disappeared from his repertory. Although still life might be thought the most stable and unchanging of all the pictorial genres, it was used repeatedly during the nineteenth and early twentieth centuries as an area of experiment. In the privacy of the studio and free from confrontation with a model, painters from Paul Cézanne to Pablo Picasso turned to still life to make their most radical moves.

The still lifes of Monet from the early 1880s, of which *Still Life with Apples and Grapes* (pl. 6) is one of the finest, are very different from his earlier, Chardinesque pieces. In the later group, he looked down on the table from a steep angle. At first sight, the arrangement of the Chicago painting seems unsteady. The table appears to slide off in a fast diagonal and the fruit to be scattered about at random. It takes a moment of looking to begin to discover the structure, which turns out to be as much a matter of his viewpoint as of the fruits' placement. The small apple at the bottom-right corner of

the canvas is like the hinge of a fan that opens out in a series of alignments spreading across the canvas. The single apple is the pivot that connects the edge of the table with the right-hand side of the picture. This has more to do with where the painter was standing and his angle of vision than with the internal arrangement of the fruit. It is the play between the geometry discovered from a particular point of view and the unstructuredness of the subject that gives the painting its expansive vitality. Look, for example, at the way the small apples on the right line up so precisely with the edge of the canvas and yet suggest that, scattered beyond that edge, there are many more apples we cannot see. These features of a downward-looking viewpoint stabilized by a found geometry came to be of immense importance in Monet's cliff-top landscapes and later in the *Water Lilies*.

Cliff Walk at Pourville, 1882

Much had happened to Monet during the five years between the paintings of the Saint-Lazare Station and *Cliff Walk* (pl. 7). Just when it seemed that Monet's finances had been secured by Durand-Ruel's support, the economy went into a lengthy recession. The dealer found himself in serious difficulties, as did many of the collectors who were beginning to buy Monet's work.

One of these was Ernest Hoschedé, the Parisian proprietor of a wholesale textile business. Besides buying generously from Monet and most of his colleagues, Hoschedé had commissioned him to paint four large decorations for his country house in Montgeron, the Château de Rottenbourg. In the summer before his Saint-Lazare paintings, Monet had stayed at the chateau and had become friendly with the large Hoschedé family.

By the following year, Hoschedé found himself bankrupt and was forced to sell his large collection, which went for knock-down prices. Camille Monet was now pregnant and in failing health. A second son, Michel, was born. Falling deeper and deeper into debt, the Monets left Argenteuil. A few months later, they took a small house in the rural village of Vétheuil, some miles down river from Argenteuil and more distant from Paris. Here they were joined by the Hoschedé family: the two parents, six children and, for a short while, several servants. This was to be a temporary arrangement, an economy to give Hoschedé breathing space to regain his footing. Meanwhile Camille's health went from bad to worse. With Hoschedé spending most of his time in Paris, Monet found himself with increasing responsibility for the two families. He became close to Hoschedé's wife, Alice, an educated and intelligent woman with some

Look, for example, at the way the small apples on the right line up so precisely with the edge of the canvas and yet suggest that, scattered beyond that edge, there are many more apples we cannot see.

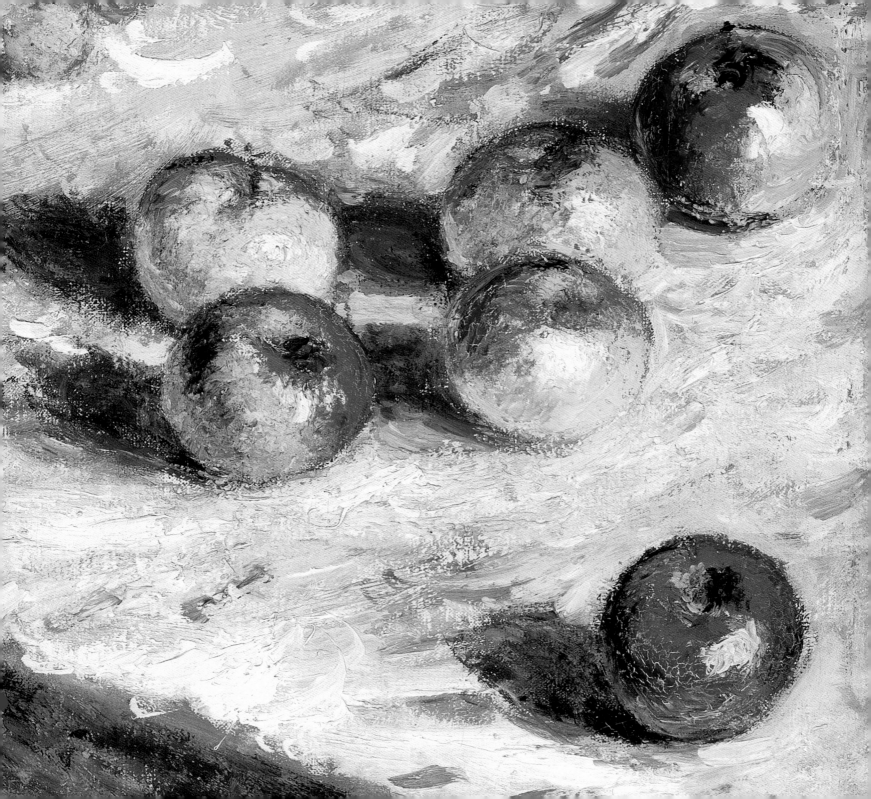

means of her own. She nursed Camille until her death, the year after the move to Vétheuil. The following winter was exceptionally severe. The Seine froze over, then flooded. The artist found subjects in these bleak events.

Without a mother since adolescence, Monet did not get along with his father, who died while the artist was in London. Thus, family had a particular importance for him, providing a necessary center. An extraordinary chain of events had left him widowed, with two young sons, as well as another, much larger family to care for. He accepted the role of protector and provider, even though the nature of his responsibility to Alice Hoschedé and her children was at first unclear. The devoutly Catholic Madame Hoschedé hesitated for some time before committing herself to a permanent relationship with the artist; in effect, the couple did not marry until 1892, a year after Ernest Hoschedé's death.

The increased demands on Monet, combined with his previous experience of hardship, combined to give urgency to his ambitions. During the winter of 1878–79, he became desperate to sell. Even his warmest admirers criticized him for letting things out of his studio that were trivial. He broke step with his colleagues and sent two large canvases to the Salon rather than join them in the fifth Impressionist exhibition, held in 1880. From now on, the artist was to display a formidable determination to sell his work. He understood very clearly the way in which the modern art market was taking shape; and he became expert at promoting his art, at playing one dealer off against another, at talking to the press, and at calculating the effect of his exhibitions. Durand-Ruel renewed his support in 1881. By the end of the decade, Monet was selling to two other dealers as well, Georges Petit and Theo van Gogh (of Boussod & Valadon); and his work was changing hands at prices that no independent painter had seen before.

But none of this was certain in the year *Cliff Walk* was painted. The two families had left Vétheuil the year before, moving to Poissy in search of a suitable school for Monet's eldest son, Jean. During the twenty-eight months that they were there, Monet spent much of his time away, painting the beaches and cliffs of the Normandy coast. The spring and summer of 1882, he was in the area of Varengeville, where he painted the first group of canvases of the customs officer's cabin, fourteen in all. During the late summer, the family joined him at Pourville. It seems likely that the two strollers seen on top of the cliff in the Chicago picture are the two elder Hoschedé girls.

It is instructive to compare *Cliff Walk* with *The Beach at Sainte-Adresse*, painted fifteen years earlier. Both depict couples absorbed in looking

out to sea, but the focus on the figures has a different quality. In the earlier painting, the man and woman with the telescope are visitors to the beach. Their crisp, city clothes contrast sharply with the gentle, pearly tones of sea and sky. To the lounging fishermen, the sea is neither recreation nor spectacle. In the later picture, sea and sky provide more than frame and backdrop to a social observation—they dominate. The two figures are consumed by wind and sunlight.

Bordighera, 1884

In the late spring of 1883, Monet moved for the last time. He rented a house in Giverny, about halfway between Paris and Rouen. It was everything that he wanted: an unspoiled, rural village set in his favorite landscape of the river plain, with easy connections to Paris. His affairs were sufficiently promising that he could hope for permanence. He was able to buy the property in November 1890, when he began serious improvement of the garden. Two years later, he bought more land, on the other side of the railway line that ran at the bottom of his garden, and it was here that he began to make his famous water garden. Within a few years, the major subject of his painting lay within the boundaries of his own domain.

But, to begin with, he was restless. He devoted the first ten years at Giverny to travel;

he could be away from home for months at a time, bringing back batches of work that he had done in the open air in places as far afield and as different from his familiar sites as Antibes and the coast of Brittany. These trips have often been described as "campaigns"; the image has persisted of the painter as a conquering, omnipotent figure, pushing back the frontiers of his painted world against whatever odds. This heroic view was supported by anecdotes of his extraordinary hardiness and courage: half-blinded by southern sun, half-drowned by treacherous tides, but still sticking resolutely to his way of working. It was a view that he enjoyed; it fit with the account of his methods that he liked to give to interviewers, describing himself as dedicated only to working out of doors, as a slave of nature whose only studio was the open sky. The truth was far more complicated.

While on these trips, he wrote to Alice Hoschedé almost every day. Judging from his letters, the campaigns were far from pleasurable. He was lonely, often staying in lodgings he disliked, eating food he despised. Always he was up against the weather. Again and again, we read of his dissatisfaction with his first attempts, with himself for starting more than he could finish; and of his frustration at changes of season, his physical exhaustion, his doubts. What drove him? Entering middle age, he was clearly at a point in

his life where renewal is the only alternative to decline. He was looking to extend his art, to test the wonderful language he had evolved in the light of the Ile-de-France against light and places that he had never previously experienced. Paul Tucker argued recently a more precise aspect to his ambition. By the 1880s, Monet was claiming for himself a place as France's premier landscape painter; as such, he needed to show that his art could encompass every aspect of *La Belle France*. Virginia Spate described his "campaigns" in less elevated terms, calling the work they produced "tourist pictures" and drawing attention to the fact that Monet was going to places that guidebooks of the day had already designated as picturesque. In her view, this body of work was calculated for a buying public and is superficial in comparison with what the artist produced nearer home.

Both of these accounts can be applied to Monet's visits to the Mediterranean; one does not exclude the other. At the end of 1883, Monet and Renoir made a trip to the south of France and northern Italy. They visited Cézanne at Aix-en-Provence on the return journey. Having first met when they were students in the studio of Charles Gleyre, Monet and Renoir had worked closely together during the summer of 1869, painting pictures that are often held to be the key works in the development of the Impressionist style. Renoir had visited Monet at Argenteuil, where they had again worked side by side. But although their friendship was as close as ever, they were moving apart in their art. Renoir had been the first to break ranks with the Impressionist group and to show at the Salon. By the early 1880s, he felt that Impressionism had no more to give, and he involved himself in a search for stronger links with tradition. It was an eclectic quest: he looked at classical antiquity and at the work of Raphael, at the art of the French eighteenth century, and at that of J. A. D. Ingres.

Monet, on the other hand, was more deeply committed to Impressionism than ever. The glimpse he had had of the South made him eager to go back. Shortly after his return to Paris, he was making preparations to work at Bordighera, just over the Italian border. In a note, he begged Durand-Ruel to keep his departure a secret: "Not that I want to make a mystery of it but because I am set on going alone: it was quite agreeable to travel with Renoir as a tourist but it would annoy me to travel together to work. I have always worked better alone and with my own impressions." He left in mid-January, "filled with ardor," he wrote from the railway station. "It seems to me that I am going to do some astounding things." Expecting to be there for about three weeks, he was set for a lightning raid on an area whose subtropical beauty was

well known and published in guidebooks. "I'll have a go at palm trees and at views that are quite exotic. Then I'll do the water, the beautiful blue water." But it was mid-April before he headed back north.

As the Art Institute's *Bordighera* (pl. 8) makes clear, he was charmed by the unfamiliar flora of the Ligurian coast and by its warm and constant light, so different from the cool, damp air of the North. But once he had embarked on his project, once he had gone beyond the tourist clichés, he found himself up against formidable problems. Anxiety struck. In his letters, he wondered what the public would make of what he was doing. People who had never seen the South or who had not looked at it properly would think that his paintings were false, even though he was, if anything, understating the case. Everything, he declared in a phrase that has often been quoted, was "flaming punch or pigeon's throat." In trying to describe the quality of the light, he employed a word—*féerique* (fairytale-like, magical)—that critics would use repeatedly in describing his later work. He was coming to terms with the limits of naturalistic color, with the immeasurable difference between the values on his palette and the values of light. To do justice to what he was seeing, he wrote to a friend, he would need a palette of diamonds and precious stones, a remark that says everything about his state of mind. He could not copy with the old mud from his paint tubes, but he could use it to invent an equivalent to the marvelous light. And in facing this issue, he was perhaps being forced to grapple as well with an aspect of his own temperament that he had tended to ignore.

Monet's art was always grounded in first-hand observation. However much he reworked his canvases in the studio, it is impossible to conceive of him painting "out of his head" or believing in anything that he had made up. In the studio, he pursued a decorative unity, but one that was authentically linked with his experience of the real world. That there was often a painful tension between the impulse toward realism and that toward decoration is obvious. Why would his working in the open air take on such a fanatical, omnipotent character unless he felt that the authenticity that it stood for was somehow threatened? There is a contradiction between Monet the realist, drawn ever closer to his subject, and Monet the aesthete, dreaming over his subject with a kind of free-floating detachment, finding the colors of the pigeon's breast and flaming brandy punch in the envelope of light and air that lies impartially over everything. As he grew older, he understood these contrary impulses in greater and greater depth. He distilled his work out of the tension between them.

"I'll have a go," Monet wrote, "at palm trees and at views that are quite exotic. Then I'll do the water, the beautiful blue water." To do justice to what he was seeing, he declared he would need a palette of diamonds and precious stones.

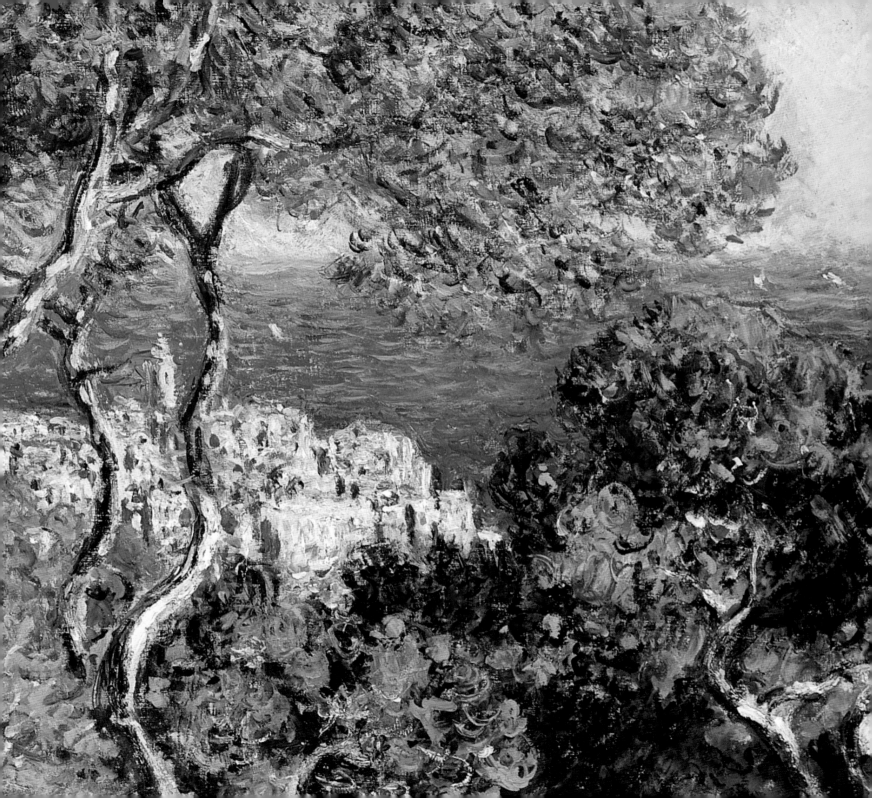

Many of the paintings Monet did at Bordighera were of a famous garden whose proprietor welcomed him. He plunged into tangled views in which palms and lemon trees and all sorts of flowering shrubs thrive together in a tame jungle. Other pictures, such as Chicago's, show wider vistas, stretches of sea of an astonishing blue, distant buildings. Here we look toward the town through a screen of olive trees. This configuration, which allows us to see the distant prospect from a position of half-concealment, has a particular power. We experience near and far in a heightened way and with a kind of excitement. The town lies peacefully in the warm light, its distance augmented by the dramatic, cranking vitality of the olive trees. Something of the old caricaturist shows here in his delight in their fantastic shapes.

Etretat, 1885

In the fall of 1885, Monet was in Etretat, a fishing village about twenty miles north of Le Havre. He returned to Giverny in December with forty-four paintings, mostly views of the spectacular chalk cliffs that flank the village, including some of the formations carved by the elements into astonishing shapes—vast arches, needles, and buttresses that were, and still are, famous attractions (see fig. 8). Many artists had worked there, including Courbet, Eugène Delacroix, and Monet himself (in the late 1860s, as well as in 1883). *Etretat: The Beach and the Eastern Rock Arch* (pl. 11) was painted from the cliff top looking down onto the beach in front of the village. There is no sign of the village, and the boats are mere accents. The composition is a long way from Monet's images of the river at Argenteuil, where signs of human activity betray his interest in the life of the moment. Here everything gives way to light, to its play on the blond cliffs and their warm reflections on the transparent sea.

One of the people whom Monet met at Etretat was the short-story writer Guy de Maupassant, who was a native of the area. Maupassant published an article in 1886 called "The Life of a Landscapist," in which he described the various encounters he had had with painters working at Etretat. It begins with a tribute to the painter's sensibility, which he claimed inspired him: "I am immersed in painting," he declared. "I live only through my eyes. . . . My eyes, open like a hungry mouth, devour earth and sky." He realized that, hitherto, he had never really looked at anything, never, above all, at effects of light. He went on to describe Monet at work, implying that it was the example of Monet which had opened his eyes. Maupassant's description of Monet painting is one of the most famous corroborations of Monet's

own version of his methods:

> Actually he was no longer a painter but a hunter. He went along, followed by children who carried his canvases, five or six canvases all depicting the same subject at different hours of the day and with different effects.

> He would take them up in turn, then put them down again, depending upon the changes in the sky. Standing before his subject, he waited, watching the sun and the shadows, capturing in a few brush strokes a falling ray of light or a passing cloud. . . .

> In this way I saw him catch a sparkling stream of light on a white cliff and fix it in a flow of yellow tones that strongly rendered the surprising and fugitive effect of that elusive and blinding brilliance.

Many of Monet's paintings depict the cliffs from sea level. With these he set himself an extreme challenge. There could hardly have been more variables to contend with: the light, the weather, the state of the sea, and the height and timing of the tide. To reach his subject, he often had to wait for the tide to drop so that he could make his scramble across slippery rocks. On one occasion, famous in the Monet legend, he miscalculated and was knocked flying by a wave. He only just crawled clear, soaked to the skin and his beard

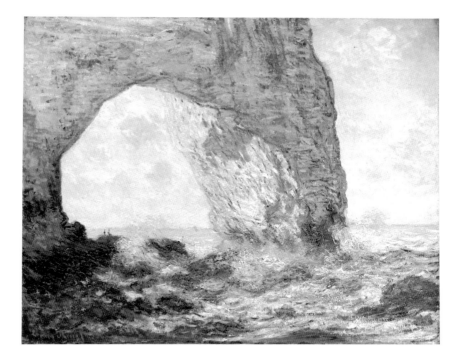

35

8. *Rock Arch West of Etretat (The Manneporte)*, 1883. Oil on canvas, 65.4 x 81.3 cm. The Metropolitan Museum of Art, New York, Bequest of William Church Osborn, 1951.

filled with paint. When the weather was too rough even for him, he worked from the windows of his lodging, as he did with the two pictures in Chicago of the fishing boats in their winter quarters (pls. 9 and 10). It is one of the great delights of the Art Institute's collection to be able to see these two pictures hanging side by side.

Like very many of the Etretat paintings, their composition is unorthodox. Here the artist's elevated viewpoint puts the horizon at the very top of the picture. The parallel planes of beach and ocean almost fill the canvas, and the boats and the strange shapes of the huts made from thatched hulls are dispersed in patterns that at

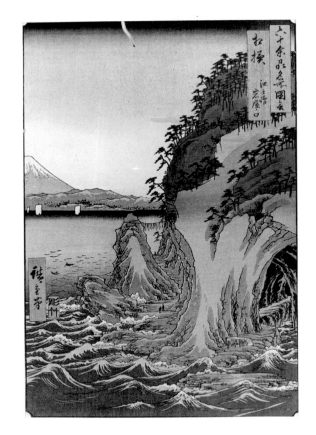

first seem random and unfocused and that only slowly reveal a strong geometry. In *Departure*, for example, the diagonals of the eaves of the buildings and the timbers in the foreground align with events out on the surface of the water to make a kind of fortuitous perspective that works powerfully against the flat expanse of beach and sea.

This kind of composition has nothing to do with the landscape tradition of western painting. It reflects Monet's love for Japanese art. He had been collecting Japanese woodblock prints for years (see fig. 9), and he continued to build this collection for most of his life. He was not of course alone in this enthusiasm. Japanese prints were admired by many of his contemporaries—for example, Degas, Manet, and Whistler. Like them, Monet learned profound lessons from the Japanese which he built deeply into his work.

The Japanese gave him ways of framing his subject that were quite different from the stage-set model he had used to such wonderful effect in *On the Bank of the Seine, Bennecourt*, ways that release the viewer from a fixed place in the "audience." New entrances open up. No longer anchored by framed perspective, the eye roams in all directions, floating free of the ground plane.

One of the most striking features of Monet's painting language is the touch of his brush. Compare the fierce jabs and slashes with which his hand responded to the black, stormy energies of the waves in the smaller *Winter Quarters* with the close-knit and gentle dabs that contribute to the warmer, less threatening atmosphere of *Departure*. In spite of their apparent immediacy and spontaneity, his marks are always controlled, indeed calculated, as if they too were among the choices he was making, like the colors he selected from his palette. Inevitably this aspect of his painting calls to mind the work of a younger artist—Vincent van Gogh—whose admiration for the Japanese equaled his own.

Rocks at Belle-Ile, 1886

"I don't know that what I will bring back from here will be to everybody's taste," Monet wrote to Durand-Ruel in September 1886, "but I do know that I am crazy about this coast." He was now writing from Brittany, from the storm-swept island Belle-Ile-en-Mer. He was about to embark on another strenuous round of open-air painting in an unfamiliar environment.

Brittany was an area of France that had been little touched by the modern world. Local customs, peasant costumes, and ancient ways of life survived. The province had great picturesque appeal, and Breton subjects were popular at the Salon. But Monet had no interest in primitive life. It was the drama of the physical landscape that he wanted. Along the coast, fierce granite cliffs confront the implacable violence of the Atlantic, and Monet was enthralled by this violence. There is an ecstatic note in his accounts of his battles with the elements. Durand-Ruel had questioned his need to go to such an unlikely place, but Monet wrote with enthusiasm about its "somber and terrible aspect" and told him that he had no wish to be only a painter of sunlight.

Several things happened in 1886 that were to affect Monet's work and reputation. The eighth and last Impressionist exhibition had taken place in the early summer without Monet's participa-

tion. He had, however, shown fifteen paintings in an international exhibition in the gallery of Georges Petit, a powerful rival to Durand-Ruel. Among the reviews had been one by the conservative writer Albert Wolff of *Le Figaro*, up to then one of Monet's most hostile critics. Writing favorably now and from an unexpected point of view, he dismissed the arguments of Monet's defenders. Monet was not a Realist but a "fantasist" with talent and charm, and he, Wolff, was interested. Nothing could indicate more clearly the turning tide of opinion than the support, however guarded, of this influential critic.

Meanwhile Monet had been reminded that he was no longer a young radical. The sensation of the Impressionist show had been the great composition *A Sunday on La Grande Jatte —1884* (fig. 10) by the twenty-seven-year-old Georges Seurat. Critics belonging to Seurat's generation, led by Félix Fénéon, were looking with unfriendly eyes at the older Impressionists. Reviewing the exhibition at Petit's, Fénéon wrote about Monet in the past tense, attacking his improvised approach to momentary effects, making fun of open-air painting. He dismissed his technique as "summary, brutal, and approximate, and full of tricks." Above all, it was unscientific. By implication Fénéon was contrasting Monet with Seurat, whose careful preparation in the studio and laborious and

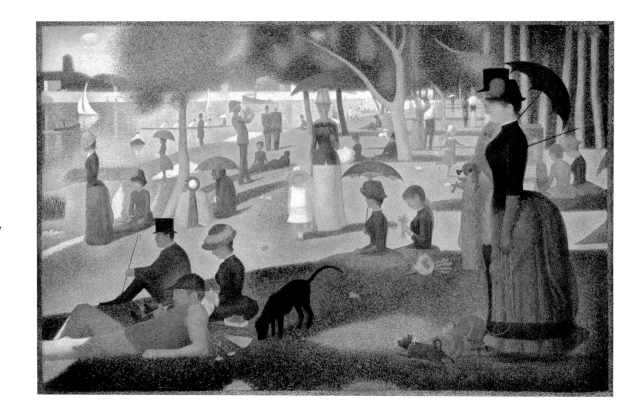

10. Georges Seurat
(French; 1859–1891).
*A Sunday on La Grande
Jatte—1884*, 1884–86.
Oil on canvas, 205.7 x
305.7 cm. Helen Birch
Bartlett Memorial
Collection, 1926.224.

impersonal technique appeared to be the exact opposite of Monet's methods.

Monet's first defenders, the Realist critics, had dropped away from him. His concentration on landscape had no bearing on what Zola demanded of modern painting. But there were several, slightly younger writers who were to become his unqualified supporters. The most interesting was the anarchist novelist Octave Mirbeau, whom Monet had met two years earlier. Mirbeau, who also happened to be a keen gardener, had a house in Brittany that Monet visited

on his way back to Giverny. He had also just met the critic Gustave Geffroy, who happened to be staying at the same inn on Belle-Ile. Geffroy, who had written favorably about Monet a few years earlier, took him for a sea captain when he walked into the inn, wrapped and booted for his latest engagement with the elements. The two became lifelong friends. Mirbeau and Geffroy, along with the journalist-politician Georges Clemenceau, constituted an immensely powerful team of supporters upon whom Monet could rely to introduce or review each new

phase of his work, to help him develop his ideas, and to defend him against the attacks of a younger generation.

The Brittany paintings, such as that in Chicago (pl. 12), live up to Monet's description of the "somber and terrible" place. The change of mood from the sunny, domestic spaces of the Ile-de-France could hardly be greater. He painted from the cliff tops, looking down onto bays and inlets and strange-shaped rocks. He had set himself an almost impossible task, given the extremes of weather and the unfamiliarity of the conditions. His letters home betray a degree of frustration that is extreme even for him. When he finally returned to Giverny, in November, he had only four canvases that he considered complete. He was to go on working on the rest in the studio for the remains of the winter. In one of his letters to Alice Hoschedé, he regretted that he had gone on with certain canvases: "I realize too late, I've only destroyed what I had done well, and since I'm resigned to bringing back incomplete things, it would have been better to have them in their purity of accent."

The Chicago picture is anything but incomplete. It is thoroughly worked in every part. The condition of light is exactly stated. Filtered through high clouds, it comes straight toward us, silhouetting the gloomy masses of the cliffs and rocks, and laying glittering paths on the water. Monet's viewpoint is high, on a level with the tops of the far cliffs. His view downward into the inlet is daring, vertiginous; and the drama is enhanced by the perspective he found there, the wedge-shape of water that drives back toward the horizon, running against the light, its momentum checked but not dispersed by the massive cone of rock in its path.

The Petite Creuse River, 1889

In the winter of 1889, Monet traveled with Geffroy and two other friends to a remote site in the *massif central* (the center of France), where two rivers, the Grande Creuse and the Petite Creuse, ran together. Geffroy knew the area. He had a friend, the poet Maurice Rollinat, who lived in eccentric isolation in a village called Fresselines. Monet was impressed by the rugged beauty of the place, with its deep valleys and dark, rock-strewn hillsides. In March he returned for a three-month working session. It was to be his last campaign away from Giverny for some years.

Of all his campaigns, this was the most taxing. The inland climate was extreme. The artist's hands became painfully chapped, and he was plagued by rheumatism. Toward the end of his stay, he wrote to Geffroy that he was exhausted to the point of illness. Never had the weather been so difficult, as was the river,

Monet's brush skipped and dragged over the humps and wedges of the hillsides, the glittering river, the narrow band of sky, finding their volume and the distances between them in a fabric of color that is more closely woven and subtle than anything that he had produced before.

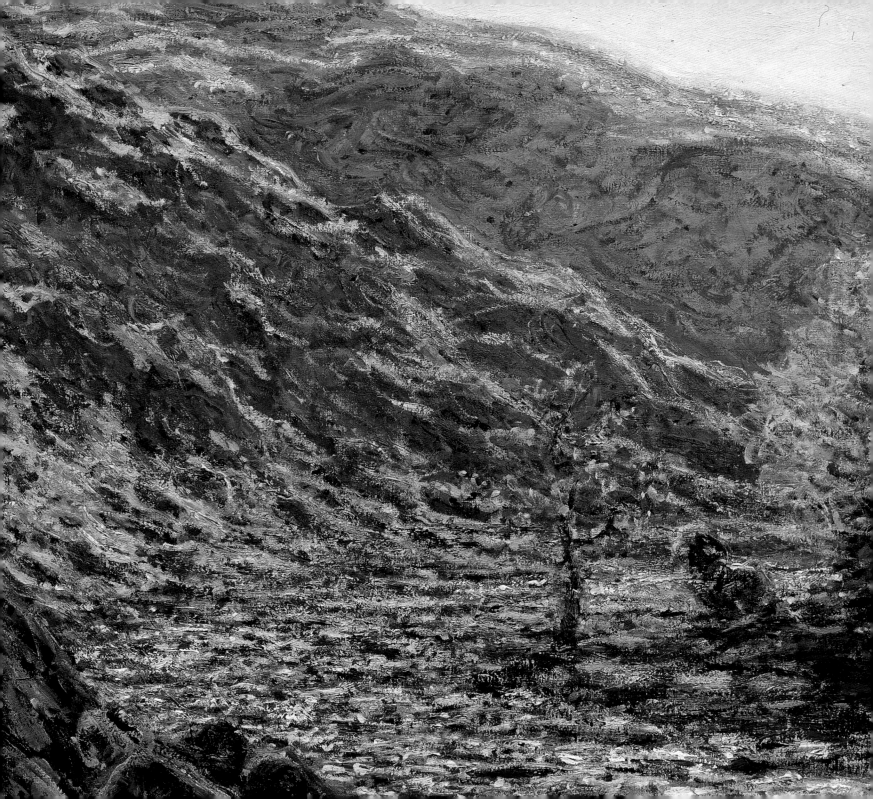

which "falls, fills up, one day green, then yellow, sometimes dry, and which tomorrow will be a torrent after the terrible rain that is falling at the moment." All his usual doubts about his work were there, coupled now with a new sense of frailty.

And yet Monet achieved something totally new at Fresselines. The paintings of the Creuse, of which a composition in the Art Institute (pl. 13) is a fine example, are more concentrated in focus and deeper in feeling than anything he had yet done on his previous trips. He completed twenty-four canvases, ten of which were painted from exactly the same spot, looking down into the valley at the river, carving its way between the steep and gloomy hills. Another, smaller group, of which the Chicago picture is one, depicts a bend in the Petite Creuse, with the flanks of the hills sloping steeply in from the left and a single oak tree at the level of the river. All of these paintings display a monumental simplicity of form, coupled with a palette that is as complex as it is uningratiating, with its discords of deep purples and oranges, sharp emerald greens and blues, lights of pink and acid yellow. The artist returned to his subject again and again, reducing it to its bare essentials: the humps and wedges of the hillsides as they fold one behind the other, the glittering river, the narrow band of sky accented by isolated trees on the skyline.

His brush skipped and dragged over them, finding their volume and the distances between them in a fabric of color that is more closely woven and subtle than anything that he had produced before.

While Monet was at Fresselines, there were other things to preoccupy him besides the work at hand. That year saw the opening of the Exposition Universelle, a major effort by the state to re-establish French cultural and industrial prestige. The Eiffel Tower was constructed as its monument. Associated with the Exposition was an exhibition of one hundred years of French painting, in which Monet was represented with three canvases. His place in the national school was confirmed. He had had a small exhibition at the gallery of Boussod & Valadon, under Theo van Gogh's direction, in which he perhaps had included one of his first paintings of wheatstacks. The show had been publicized with long, appreciative articles by Geffroy and Mirbeau. And in June there was to be a large retrospective exhibition, shared with the sculptor Auguste Rodin, at the Galerie Georges Petit, timed to take advantage of the influx of visitors to the Exposition Universelle. Monet understood very well what an opportunity this was to establish himself with an international audience, and he worked hard to persuade collectors to lend. He ended up with 145 paintings, examples from almost every year

of his career since 1864. These included large groups from the campaigns in Belle-Ile, Antibes, and the Creuse. Of the thirteen canvases of the Creuse, all of which he hung together, at least five were of identical views. He had never done this before. The exhibition was a tremendous success, both with the critics and with the visitors, many of them from the United States. Monet's prices were rising. That September it was reported that Theo van Gogh had sold a Creuse painting to an American for the remarkable price of nine thousand francs.

Much of Mirbeau's long introduction to the catalogue must have been inspired by conversations with Monet himself. There was a good deal of special pleading, not all of it truthful. Monet was the greatest painter alive, Mirbeau claimed. He had turned his back on tradition. He had no master but nature, no studio but the out-of-doors. His technique—his capturing of light in color rather than in tonal contrast, and his vigorous, broken brush stroke—was not the improvisation of a sketcher but the considered process of an artist who, uniquely, was working in the empirical spirit of science. For this reason, Monet would only work while an effect lasted. He would go back to the same spot at exactly the same time of day, to pick up his search again by the same light. Sometimes, Mirbeau claimed, the artist was forced to do this in as many as sixty

sessions. This was the view of Monet's methods that became, so to speak, the official line. It was the way that Monet told it for the rest of his life and the way that subsequent critics, friendly or otherwise, understood him. Later opinions tended to ignore the other side of Mirbeau's account, which insisted on the metaphysical implications of Monet's "dream." The purpose that ran through all his work was not mere naturalism but, by joining nature and art, to uncover universal, pantheistic connections.

The opportunity the retrospective gave Monet to review nearly thirty years of work, his consciousness of aging, and his new financial security must all have combined to bring about changes in his outlook. His art took on a different character now, a quality of focus and purposefulness that was to be most clearly demonstrated in 1891, with the exhibition of the *Wheatstacks* series. He condensed the extraordinary range of his oeuvre, which gained in subtlety and substance what it surrendered in variety.

Poppy Field (Giverny), 1890–91

During the early summer of 1890, after a long interruption from work, during which he had been involved in organizing a public subscription for the purchase by the French nation of Manet's *Olympia*, Monet wrote to Geffroy that he was depressed and disgusted with painting. He had

achieved nothing new, and the few things that he had done were now scraped and slashed. On top of everything, his rheumatism was troubling him, the reward for all his hours working in the rain and frost. He was beginning to feel his limitations. It is the letter of a strong man facing advancing age: he was soon to turn fifty.

Then he began to paint in the fields near his house in Giverny. The crops were standing. He worked at two sites, one the corner of a field of oats, the other a field of poppies, where *Poppy Field (Giverny)* (pl. 14) was painted. Both compositions were extremely simple, and he repeated them several times from exactly the same spot under slightly different conditions of light and atmosphere. The paintings are densely worked, over many sessions, the paint surface built layer upon layer, the later layers not canceling the earlier ones but responding to and augmenting them. The difference between each picture is not dramatic but a matter of nuance, finely observed degrees of difference in the quality of the atmosphere and the way in which it carried its charge of light.

Wheatstacks, 1890–91

"I saw [the collector Georges] de Bellio yesterday," Pissarro wrote to his son in London. "He mentioned that Monet is going to have a one-man show at Durand-Ruel's and exhibit *nothing but wheatstacks*. The clerk at Boussod & Valadon told me that the collectors want only wheatstacks. I don't understand how Monet can submit to this demand that he repeat himself— such is the terrible consequence of success!" It was a famous misunderstanding, one that Pissarro quickly revised when he saw the exhibition. Far from repeating himself, Monet was doing something he had never done before. He showed fifteen of the *Wheatstack* canvases so that the viewer could see them as a complete series. This gave a new meaning to repetition and a new way of reading his intentions.

Monet had been showing the *Wheatstacks* to visitors for some time before the exhibition opened and had encouraged competition between collectors. By the time the works were put on view, all but five had been spoken for and, by the end of the year, twenty out of the thirty finished paintings of the subject were sold, many to Americans. One of the visitors to the exhibition was Bertha Honoré Palmer, wife of Chicago hotel owner Potter Palmer, who bought no fewer than nine. It is largely due to her that the Art Institute today has six canvases from this series (pls. 15–20).

It is extremely difficult to pin down the meaning of the *Wheatstack* pictures, whether considered one by one or as a series. Monet himself encouraged an extremely simple inter-

pretation. He told an interviewer that he had been working from one of the stacks. The light changed, and Blanche Hoschedé was sent back to the studio for another canvas, then another, and another. "It is not very difficult to understand!" This vastly over-simplified account would do as a scenario that his audience could easily grasp, and as a screen that protected him from the difficulties of a more searching response.

Toward the end of summer, the harvest was reaped and the grain crops—wheat and oats—were built into stacks where they would stand for some months before being threshed. Now referred to as "wheatstacks," these structures have also been described as "haystacks" and "grainstacks" in what remains a matter of some debate. Monet had painted them before; he now returned to them with all his concentration. In an important and much-quoted letter to Geffroy, he wrote:

> I am hard at it; I am bent upon a series of different effects but at this time of year the sun declines so quickly that I cannot follow it. . . . I have become so slow in my work that I am exasperated, but the further I go, the more I see that one has to work a lot in order to express what I am looking for: "instantaneity," above all the atmosphere, the same light diffused everywhere, and more than ever I am disgusted by easy

things that come at once. In short, I am more and more determined to render what I experience and I pray that I may live longer and have strength because it seems to me that I am making progress.

The painter's optimism and excitement are obvious in this fascinating statement, the polar opposite of his despair of a few months earlier. And yet, by his own account, he seems to have trapped himself in a curious bind—needing to work more slowly and to renounce his brilliance at capturing the moment, in order to capture the moment! "He stayed at the edge of this field that day," Geffroy stated in one of the best passages he ever wrote about his friend's work,

> and returned the next day and the day after and every day until autumn and through the whole of autumn and the beginning of winter. . . . These stacks, in that deserted field, are transitory objects on which are reflected, as on a mirror, the influences of the surroundings, atmospheric conditions, random breezes, sudden bursts of light. They are a fulcrum for light and shadow; sun and shade circle about them at a steady pace; they reflect the final warmth, the last rays; they become enveloped in mist, sprinkled with rain, frozen in snow; they are in harmony with the distance, the earth, and the sun.

*"These stacks, in that deserted field,
are…a fulcrum for light and shadow;
sun and shade circle about them
at a steady pace; they reflect
the final warmth, the last rays;
they become enveloped in mist,
sprinkled with rain, frozen in snow;
they are in harmony with the distance,
the earth, and the sun."*

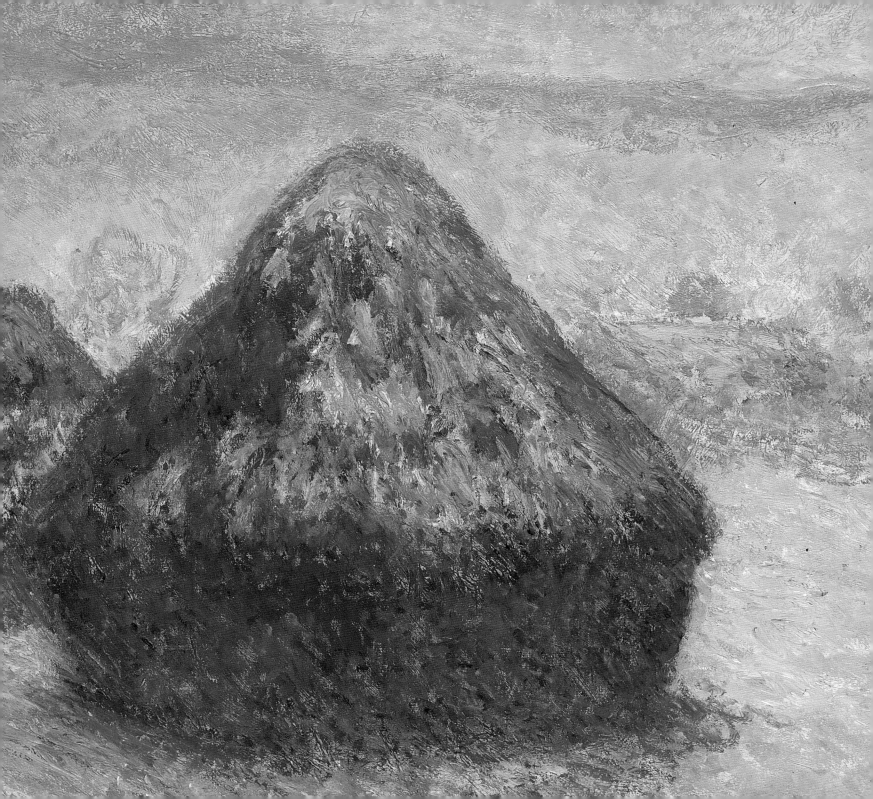

One of the visitors to the exhibition at Durand-Ruel's was a Dutch philologist named Willem Byvanck. He published an account of his visit. His first impression of the *Wheatstack* pictures was one of disorientation. He wanted to leave. His eyes were hurt by "these gaudy colors, these zigzag lines, blues, yellows, greens, reds, browns dancing a crazy saraband on the canvas." But, finding himself alone in the gallery, he took time to look more closely. One picture in particular drew his attention. "The purple and gold rays of an afternoon sun ignited the straw, the burning stalks blazed with a dazzling brilliance. The hot air visibly vibrated and bathed objects in a transparent, blue haze. . . . The observer's eye was irresistibly compelled by this medley of colors to re-create the artist's vision." Encouraged by his experience of this one painting, Byvanck looked at more. It "taught me to see the others; it awakened them to life and truth. . . . I now felt a rare delight in perusing the series, . . . from the scarlet purple of summer to the chilly gray of a winter evening's dying glow."

At this point, Monet himself walked into the gallery. Byvanck told him what he had just experienced. Monet endorsed it, saying, "Above all I wanted to be truthful and exact. For me a landscape hardly exists at all as a landscape, because its appearance is constantly changing; but it lives by virtue of its surroundings—the air and light—which vary continually." Monet told Byvanck that he had got it right with the picture he started with: "That one alone is completely successful. . . . As for the rest, there are some that really aren't bad, but they only acquire their full value by comparison and in the succession of the full series." Byvanck had realized that it was the series as a whole that conveys significance, not as a row of isolated observations and not as a chronological sequence, but as a complex aesthetic experience in which the color organization of one painting gives meaning and precision to the organization of another.

Painting does not happen instantaneously, and the *Wheatstacks* are the least sketchlike pictures one can imagine. Clearly the realization of this series was an act of memory as much as it was an observation of the instant. Monet's perception of his subject matter had changed. His interest was focused now on what he called the *enveloppe*, the atmosphere itself, the light that suffused it, its inclusiveness. Compare *Wheatstacks (End of Summer)* (pl. 15) with the *Belle-Ile* canvas: the rocks and sea lie before us and their character—massive, glittering—is qualified by the light that breaks off their surfaces. But with the *Wheatstacks*, light and atmosphere lie between us and the stacks. Their surfaces are furred by it, buried in light. A new kind of unity joins the long bands of sunlight in the foreground with

the wooded hills in the distance and even the pointed silhouette of the stack with the sky itself. Monet executed the painting layer upon layer, as though, at every point, he was imagining a transparent thickness and as though, at every point, he knew his marks must signify more than one thing. His brush moved as if to break open boundaries. Notice how he drew the right-hand side of the larger stack with red and then moved the same red outward to the right side of the canvas, opening the shape of the stack; or how every area of the picture shares something with every other area: the clear lemon of the sky is an ingredient woven into the texture of the earth, and the reddish purple of the stack spreads in finely adjusted increments into the foreground and into the distance.

The paintings with two stacks (see pls. 15–17) make some concessions to spatial composition. The line of trees and the far edge of the field have parts to play in the way our eye moves through the picture. It is with the single stacks that we feel the full force of the artist's new concentration, above all in the superb *Wheatstack (Thaw, Sunset)* (pl. 19), arguably the masterpiece of the series. Now the field, hillside, and sky face us square on, in frontal bands. The tip of the stack nearly, but not quite, touches the horizon at a crucial point in the geometry of the canvas, on the square of the shorter side. The powerful

russet of the stack modulates into orange light in the foreground and in the heart of the distant hill. The purple-blue of the hill splits into violet and blue as it moves toward us over the snow. The sky, simultaneously blue, violet, orange, and yellow, is everywhere; and its luminescence seems to hang between us and everything we can see.

Sandvika, Norway, 1895

The year after the *Wheatstacks* were exhibited, Monet began his paintings of the facade of Rouen Cathedral. He worked on them for several years, both in Rouen and back in his studio at Giverny. They were due to be shown the spring of 1895, but the exhibition was postponed. The reason was that Monet went to Norway to visit his eldest stepson, Jacques Hoschedé, who had found work there. News of his coming had preceded him; his train would have been met in Christiana (now Oslo) by a welcoming committee of Norwegian painters, but Hoschedé stopped them. Everything was under snow, and it was some time before Monet could find anything to paint. He was taken to Sandvika, a village on the Christiana fjord where there was an artist's colony. Here he worked on views of the village (see pl. 21) and of a mountain, Mount Kolsaas, astonishing his Norwegian colleagues by painting out of doors. "You would have laughed," he wrote

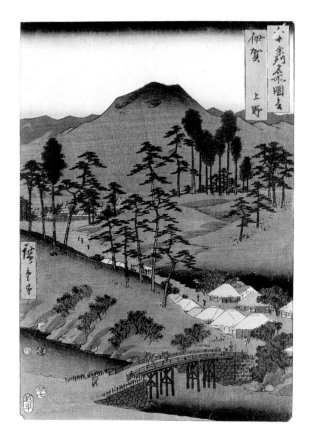

"I shouldn't be showing that picture in this state," Monet told the prince. "I am trying to get it into shape. It is costing me a great deal of difficulty."

Monet knew that his sense of the Norwegian landscape was superficial. He told Geffroy that he would need to live there a year in order to understand it. It reminded him of Japan, he said: Mount Kolsaas was like Mount Fuji. He was talking of a Japan he could only imagine through his beloved Japanese prints (see fig. 11), and indeed there is something fanciful and even unreal about the Chicago picture of Norway.

Customs House at Varengeville, 1897

Perhaps the most interesting remark that Byvanck made was when he spoke about the observer's eye being "compelled by this medley of colors to re-create the artist's vision." It reminds us of the central fact about Monet's art: he painted what he saw. Working from observation means standing in a particular place, looking in a particular direction, and taking what is given by the world as the material for a picture. The two figures with their telescope on the beach at Sainte-Adresse represent the act of looking, and they are given to us within a world that derives all its features from Monet's own looking, not only the topography of the place, the weather, the time of day, but also his actions in describing it. The movements of his hand that

to Geffroy, "if you could have seen me completely white, with icicles hanging from my beard like stalactites." The community of painters knew that they had a celebrity in their midst, and they fêted him, taking too much interest in him for Monet's peace of mind. One visitor, however, seems to have pleased him. This was Prince Eugen of Sweden, himself an amateur painter, who was taken to meet Monet in the hotel rooms in Christiana that the artist was using as his base. Monet showed him work in progress, which included, interestingly, one of the Rouen facades.

we read in the picture, the decisions embodied in his color choices, the changes from one value to another, and the way all this is put together, compel us to "re-create the artist's vision." This sense of his vision brings us imaginatively into his presence, and into his present. We cannot escape the mystery of time in front of Monet's paintings. We cannot place his pictures at an historical distance as we can those of a Claude Lorrain or of a J. M.W. Turner, for to engage imaginatively with a Monet is to enter into his here-and-now.

The painting *Etretat* comes as close as we can imagine to Maupassant's description of Monet as a sharpshooter. Maupassant's conceit was to pretend that Monet's art came about on the instant, which of course it did not. Even so, to look closely at the picture is to enter Monet's time, from which, as far as possible, memory and anticipation have been excluded. He was obsessed by the wonder of how things looked at a particular moment. His frustration stemmed always from a conflict with the moment. No matter how he cleaved to its truth, there was still the anxiety of its passage, and of knowing that he might never recapture it. "La nature ne s'arrête pas" (nature never stands still), he told the American painter Theodore Robinson. Another American artist, Lilla Cabot Perry, recounted a separate conversation with Monet: "He told me that, in one of his *Poplars* [fig. 12], the effect

lasted for only seven minutes, or until the sunlight left a certain leaf. . . . He always insisted on the great importance of a painter noticing when an effect changed." And Monet told her that to do this was his only strength: "It is the only power that I can claim."

The moment was his hold on the truth and, as long as he could maintain that connection,

12. *Poplars (Autumn)*, 1891. Oil on canvas, 92 x 72 cm. Philadelphia Museum of Art, Gift of Chester Dale.

13. *Customs House East of Varengeville,* c.1882. Oil on canvas, 65 x 81 cm. The Metropolitan Museum of Art, New York.

he could defend the authenticity of what he was doing. But there is something absurd and self-defeating about this commitment, about gambling that a certain moment will come back tomorrow, or if not tomorrow, next week. Nature never stops—he knew this only too well. To do justice to this movement, he would need to bring nature to a standstill. The craziness of that paradox is reflected in a famous incident from the campaign at the Creuse, when an oak tree sprouted leaves in the spring and Monet hired workmen with ladders to strip them off again.

The device of the series addresses these contradictions and offers a synthesis. The repetition of a single motif—whether a wheatstack or a cathedral facade—is like a drumbeat thumping out a continuity. And Monet's working methods, much slower now, brought a sense of continuity to the picture surface: instead of quick, fresh brush strokes juxtaposed side by side, there is a thick, layered accretion arrived at over time. Colors were broken in depth, one thing happening after another. The moment of the motif—the gleam of light, the evanescent veil of atmosphere—came increasingly to be registered in a context that asserted duration.

As the years passed, Monet felt the need to revisit his old painting grounds. The journalist François Thiébault-Sisson remembered Monet talking about a plan to return to "all the stations of my life as a painter and to verify my former emotions." No doubt this was partly the nostalgia of a sixty-year-old for the days of his youth. But nostalgia on Monet's part was something new, and behind it we can make out an understanding of time that is far more complex and difficult than his earlier sharpshooting chase after the present instant.

The summers of 1896 and 1897 found Monet back on the Normandy coast at Varengeville and Pourville, places he had known since his youth and had painted repeatedly in the early 1880s. Chicago's *Customs House at Varengeville* (pl. 22) is one of eleven new versions of an old and much-loved subject (see fig. 13). A number of such

buildings had been erected along the Channel coast at the time of Napoleon I to control smuggling during the continental blockade. Since then, this one had been used for storage. Monet was pleased to own a key. Clearly this unremarkable structure had a particular hold on his imagination. Isolated, steadfast, perched on the brink of land, facing the infinity of sea and sky, the building may well have resonated for the artist on several levels; he could have found in it, not only an inanimate and enduring version of the observer theme, so important in his early work, but a personal symbolism that gave back to him, on its own terms, a robust view of himself. The strong, triangular shape of the cliff and cabin juts out as forcefully as any wheatstack. The moment of light—the thinning sea mist, the wet gleams of filtered sunlight—is as precise as ever, but the iridescent and almost indescribable color and the smoky layering of the paint seem to place the cabin at a distance in an atmosphere of reverie. We cannot avoid the feeling that Monet was remembering as he looked, that there is a note of introspection in his looking, and that the effect of light he was reconstructing on the canvas had a meaning that carried beyond the moment.

Mornings on the Seine, Giverny, 1897

Back in Giverny, Monet started on a new series, working from his floating studio. This too was a return, not to a particular place but to a type of subject that he had painted at Argenteuil, at Vétheuil, and already at Giverny, a motif of the riverbank overhung with trees and their reflections in the endlessly moving water. Although the *Mornings on the Seine* track the changes of light as dawn breaks over the river in a more precise chronology than he was to follow in any other series, the formality and calm of their structure seem to place them beyond the passage of time.

In France the proportions of artists' canvases are traditionally categorized by subject. There are figure canvases, landscape canvases, and marine canvases, the last being the longest and narrowest. The most symmetrical shape, the square, was associated with decoration. The Chicago *Morning on the Seine* (pl. 23) is 89.9 by 92.7 centimeters—just off square—and this is typical of the whole series. It is an important fact. Monet had not employed this shape much before. He was later to use it often. Here he approached the square as a kind of mirror to his subject, locking the symmetry of one onto the symmetry of the other. The reflections of the trees are as important as the trees themselves. The lowest tip of the overhanging foliage and its reflection point at each other along the central vertical axis of the canvas. Less clearly seen in the misty Chicago picture, but quite clear in other versions where the sun is higher, the distant

bank of the river is drawn on the central horizontal axis of the canvas.

These are extreme paintings. Monet gave us an image that seems, by its symmetry, to be free from the contingencies of observation: we have nowhere to stand, nothing fixes us to a particular viewpoint or orientation. The Chicago canvas could be hung upside down and make perfect sense. We must surrender something as we look at this firm, still image. There are few thresholds for our eye to grasp, little to name. We are invited to look slowly, to give ourselves over to reverie. And the marvelous paradox is that this sense of timelessness, so far beyond the quotidian, is arrived at in terms borrowed from a moment, a few minutes at most.

When the *Mornings* were exhibited, several critics invoked the name of Camille Corot. Dawn, the subject, had been his time (see fig. 14). A large Corot exhibition was on view in 1895, at the same as Monet's paintings of Rouen Cathedral were being shown. Monet shared the general opinion that Corot was the foremost landscape painter of the nineteenth century. It seems plausible that the *Mornings* were in part conceived as a tribute to the older artist, and also intended as a challenge, as Monet's bid for a place in a long and venerable tradition. But his

riverbank, in its dewy silence, is not the background for dancing nymphs: it is ruled by the actuality of what he saw, which for him, as Mirbeau had once famously observed, was the only wellspring of his dream.

London

"Without the fog, London would not be a beautiful city," Monet told the dealer René Gimpel in the 1920s. "It is the fog that gives it its magnificent breadth." He had not done much painting while he was in London during the war of 1870. The best thing that had happened to him during those unhappy months had been his meeting Durand-Ruel. Pissarro had been in London too, and he and Monet had spent time in the museums, where they got to know the work of the English landscape painters John Constable, John Crome, and Turner. The art of Turner in particular had significance for Monet. Turner's *Rain, Steam, and Speed* (fig. 15) was one of the very few paintings that Monet ever named as being important to him.

Monet returned to London several times: for two weeks in 1887, when he saw Whistler; in 1891, when, thanks to Whistler, he showed work with the New English Art Club; and again in 1898 to visit his son Michel, who was studying English there and had fallen ill. He must have

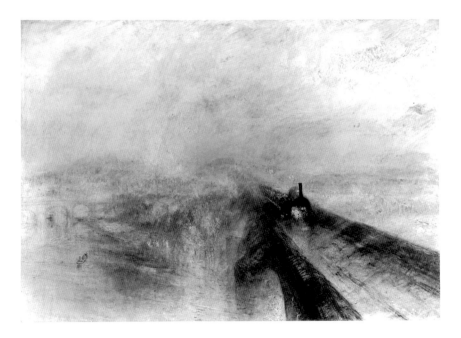

talked about wanting to paint in London, because, as early as 1891, Pissarro wrote his son that "Everyone is awaiting Monet's London series." He finally went there to work in the autumn of 1899.

This marks the end of Monet's exploration of the landscape of France beyond the boundaries of his own domain in Giverny. Paul Tucker has speculated that what prompted him to go to London at this particular moment was a feeling of despair at what was happening at home. French society was gripped by the scandal of the Dreyfus Affair (the movement to vindicate the Jewish captain, convicted for espionage in 1894, had mushroomed into a scandal implicating top

15. J. M. W. Turner (English; 1775–1851). *Rain, Steam, and Speed—The Great Western Railway,* 1844. Oil on canvas, 91 x 122 cm. The National Gallery, London.

military and government officials in the miscarriage of justice). In an atmosphere poisoned by anti-Semitism masquerading as patriotism, and official lies and cover-ups in the name of military honor, everyone took sides. Old friendships were split. Cézanne, Degas, and Renoir all sided with the army. Zola's *J'accuse*, the crucial instrument of Dreyfus's ultimate acquittal, was published in Clemenceau's newspaper, *L'Aurore*. As soon as it appeared, Monet had written to his old friend in ardent support, and he had signed a "Manifesto of the Intellectuals" demanding a response to Zola's accusations. He had no desire to be drawn more deeply into political action, however; his action was to paint. But the vision of *La Belle France* embodied in the *Mornings on the Seine* and in his recent paintings of the Normandy coast may have seemed impossible to sustain.

He took Alice Monet with him to London, and they stayed at the fashionable Savoy Hotel, situated between the Strand and the north bank of the Thames, which their rooms overlooked. From there Monet could look downriver to Waterloo Bridge and beyond to the factories of South-wark; or upriver, to his right, toward the railway bridge running out of Charing Cross Station and beyond it to the Palace of Westminster. He found a third viewpoint on the south side of the river, on the terrace of St. Thomas's Hospital, from which he could look straight

across the river to the Houses of Parliament. All three of these views are represented in the Chicago collection (pls. 27–30).

His first visit lasted six weeks. He returned the following year, this time for three months, and again for a similar period in 1901. Numerically his London pictures constitute the largest series that he painted away from home. The results were eagerly awaited by Durand-Ruel, but every time that Monet came back from London he put the dealer off, telling him that he had nothing but beginnings.

During the 1900 session, Monet was visited by Geffroy and Clemenceau. Years later Geffroy remembered:

Now and then he would stop, saying,
"The sun is gone." In front of us, the
Thames rolled its waves, almost invisible
in the fog. A boat passed like a ghost.
The bridges were barely discernible in
that space, and on them an all-but-imperceptible movement gave life to the mist's
opacity: trains passing each other on
Charing Cross Bridge, buses streaming
across Waterloo Bridge, wafts of smoke
that soon disappeared into the thick and
livid vastness. . . . Suddenly Claude Monet
grabbed up his palette and brushes.
"The sun is out again," he said, but at that
moment he was the only one who knew it.

Look as we might, we still saw nothing but that gray, muffled space.

He worked in his usual way, starting a new canvas for each effect, but he was quickly in trouble. Minute changes in the density of the famous fog happened so fast that soon he had more canvases started than he could keep up with. Years later he told an interviewer about his feverish searches for the canvas that corresponded to the effect of the moment and how he often chose the wrong one. As had happened so many times before, he found himself torn between the alternatives of making quick studies of momentary effects and trying to develop them further. He wondered whether it was possible to paint directly in England: "I should have done nothing but sketches, real impressions." When he went back for his final campaign, in 1901, however, he brought no fewer than eighty canvases that he had already started. The London paintings were not exhibited until 1904, nearly five years after Monet had begun work on them.

The two Waterloo Bridge pictures in the Chicago collection are perfect companion pieces: one depicts morning, with the sun coming from the east, silhouetting the bridge against the light (pl. 30); the other, late afternoon, with sunlight warming the side of the bridge and picking out the traffic in spots of orange (pl. 27). Both are momentary effects, brief openings in the smoke-laden blanket that makes the sky thick and the buildings insubstantial. What is most remarkable about these pictures, which must have been completed over time in Monet's studio, is how he was able to consolidate these brief effects, to bring memory and his incomparable understanding of his palette to bear on what was in all likelihood a very slight sketch, perhaps the work of a few minutes. In each case, the key decisions must have been focused on how certain color chords were to re-create the particular quality of light. In the morning picture, this would be a blue-gray working with a range of golden yellows, from the pale brilliance under the bridge to the tarnished brown-gold of the sky. In the afternoon picture, it is a violet-blue working with a red-gold that suffuses the whole surface, hanging between us and the river, turning the factory smoke to rose.

It had been many years since Monet had concerned himself with cities and the signs of industry; and now that he did, it was certainly not as the social observer that Zola had once taken him to be. None of his paintings better match the epithet *féerique* than the London scenes. The train that steams across Charing Cross Bridge is a figment. The silhouette of the Palace of Westminster, with its Gothic Revival pinnacles and towers, becomes the vessel of everything in Monet's temperament that was romantic. The

"Now and then, he would stop, saying, 'The sun is gone.' In front of us, the Thames rolled its waves, almost invisible in the fog…. Suddenly [he] grabbed up his palette and brushes. 'The sun is out again,' he said, but at that moment he was the only one who knew it. Look as we might, we still saw nothing but that gray, muffled space."

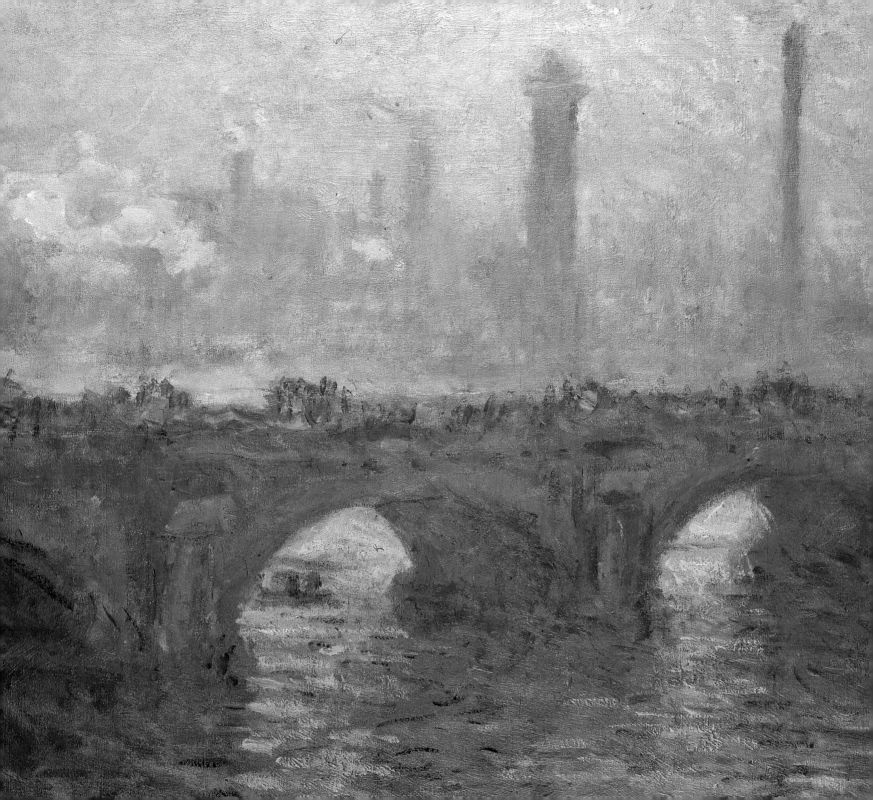

soot-laden fog, bane of every Londoner's existence, was for him the very medium of dreams. There is one painting of Waterloo Bridge (in the National Gallery of Canada, Ottawa) where the fog allowed him to paint the sun itself, as it had years ago in the famous sketch of the harbor at Rouen, *Impression, Sunrise* (fig. 6), which had given a name to a whole movement. When he had been in London as a young man, he had painted the Houses of Parliament and Big Ben, but from ground level. Now, looking down from his lofty balcony, he must have reflected with some wonder on past emotions and on the "stations of [his] life as a painter."

Vétheuil, 1901

When Monet returned to Giverny after his last London visit, he seems to have put the London paintings aside for a while. When he took them up again, it was to do more than merely retouch them. There were substantial reworkings. During the summer, he painted a new series (see pls. 25 and 26), again going back to an old subject. The church at Vétheuil was some miles from Giverny, and Monet traveled there in his new motorcar. His stepdaughter Suzanne, Monet's favorite model, had died. Both he and his wife were mourning deeply. There must have been some connection between this sadness and his return to Vétheuil, the place

where Camille had died and where he and Alice had started their lives together some twenty years before. In these canvases, personal memories and memories of work were interwoven. Monet had painted the same view of the church in 1879, a picture that had acquired a particular meaning for him (fig. 16). It was a scene in thick mist, the church barely visible. A collector had looked at the picture at the time and had rejected it, finding it too white and too unfinished. Later Monet refused several offers for it. It had become a talisman in his studio, standing for his right to decide when a picture was complete and as a harbinger of his new insights about light and atmosphere. He had shown it in no less than four exhibitions in the late 1880s, including the great retrospective of 1889. All this must have come back to him as he worked on the new series.

The two Vétheuil canvases in the Art Institute's collection provide a particularly good opportunity to reflect on the rewards of Monet's attention to light and atmosphere. The compositions of both paintings are virtually identical—if, by composition, one means the placement of items within the rectangle of the canvas. Both versions are high in tone, with little contrast: they depict a misty, late-summer light. But in one, it seems, the light is that of midday, and, in the other, that of the afternoon. In the afternoon painting, the atmosphere is thicker and suffused

with a mysterious warmth—mysterious because we see through warmth to cool blues and violets. Atmosphere reduces contrasts of light and dark to a minimum. We move through the picture from notes of lilac to gold to rose to lemony green, all pale, all equally luminous. If anything dominates, it is the rosy pyramid of the town and its inverted reflection. In the noon painting, only slightly misty, the darkness of the trees along the riverbank gives a distinct articulation, separating the river from the land and bringing a different order of contrast to bear. Now the town looks white. The top of the church tower, dark against the sky, has a quite different expression. Difference in identity, identity in difference: the two pictures epitomize the endless possibilities of Monet's intercourse with light.

Water Lily Garden (The Japanese Bridge), 1900
Water Lilies, 1906

Ever since the *Wheatstacks* had been shown as a series, Monet had been aware of the special meaning of an ensemble. As each succeeding series had been seen—the *Poplars*, the *Rouen Cathedrals*, the *Mornings on the Seine*—critics had deplored the fact that the groups would be broken up as their component parts were sold. The idea came to him of making a complete decorative scheme out of his paintings of the

water lilies in a permanent setting. He described it to a visitor in the late 1890s: "Imagine a circular room in which the dado beneath the molding is covered with paintings of water, dotted with these plants to the very horizon." Monet did not act on this idea until 1914. Meanwhile, in the summers of 1899 and 1900, between his visits to London, he concentrated on the Japanese bridge in his garden. What resulted are closed, almost claustrophobic images. In *Water Lily Garden (The Japanese Bridge)* (pl. 24), there is no sky. Long streamers hang down from the weeping willow like a curtain. Space ends in a wall of foliage. The sunlight beats down from above, burning the rails

16. *Vétheuil in Fog,* 1879. Oil on canvas, 60 x 71 cm. Musée Marmottan, Paris.

61

By now Monet had been obsessed by
the water-lily motif for twenty years.
In these works, he looked at fragments,
close up, their scale transformed
by his large brushes and his way
of thinking about the canvas,
not as a window but as a decorative
surface imagined almost as
the surface of the pool itself.

of the bridge, glittering up from the water. The place is enclosed, and a sultry silence hangs over it. Some of the pictures in this series are finished in an almost embroidered detail, the floating lilies making a precise perspective.

It is possible that Chicago's *Japanese Bridge* is unfinished, and that the bold strokes of saturated color are a stage of the painting that Monet intended to work over. In other versions of the subject, he built a highly nuanced and elaborate surface out of broken, dragged strokes, leaving the earlier layers of paint to smolder like embers below. This interplay between different applications of color was brilliantly calculated, involving the interaction of color, the scale and pacing of the stroke, and even the texture and degree of wetness or dryness of the underpaint. One only has to glance at the surface of the Waterloo Bridge pictures to see that, when Monet now worked in the studio, he was doing far more than making minor adjustments: he was constructing an extremely complex visual event.

This noted, one has to admit that the color of *Japanese Bridge*, as we see it, is astonishing. What does it describe? What is the source of that red patch under the bridge, or those shots of red, spattered like drops of blood among the floating leaves and running down the side of the weeping willow? All these features—fierceness, discordance, arbitrariness—appear in Monet's

work during the last twenty years of his life. They are often associated with his deteriorating eyesight. The Chicago *Japanese Bridge* shows that the uningratiating attitude that produced them was present long before.

For the last decade, Monet had been preoccupied with atmosphere, with the luminous veil between him and the forms of his subject. His attention to this veil had freed his color from traditional descriptive attachments: mist charged with a certain light made brown buildings pink and then violet, dark elms blue. Light did not have a local color. Here the Japanese bridge and the weeping willow are too close and too fiercely lit for atmosphere to come between. But the freedom of Monet's palette was irreversible, and he exploited that freedom with passionate daring.

When Monet returned to the pond after the London pictures were at last resolved, he took an even more radical approach. Rumors began to circulate about new paintings in which there was nothing to see but reflections. An exhibition was planned for 1907, but, when the time came, Monet told Durand-Ruel that he had only five or six canvases ready and that he had destroyed at least thirty others, "to my great satisfaction." The news of this massacre got out and was reported internationally in the press. The *Washington Post*'s headline speaks for itself: "Monet,

the French artist, wrecks works worth $100,000."

The Chicago *Water Lilies* (pl. 31) is one of the canvases that escaped. It exemplifies the new kind of picture that Monet was inventing on the banks of his pond and intimates the extraordinary difficulties that he had set for himself. "No more earth, no more sky, no limits now," Roger Marx wrote in a brilliant article that appeared when the new pictures were at last shown. "He wants attention diffused and scattered everywhere." Looking down into the pond at a steep angle, Monet no longer included the far bank, thus leaving us without foothold or horizon. Inevitably this brings about a radical change in the way we look at the canvas: it is now much harder to see it as if looking through a window, the convention that gives us our orientation even in paintings like the *Customs House* or *Charing Cross Bridge*. Now we must start with the picture's surface. In our time, familiarity with abstract art prepares us for this. But it is important to remember that Monet was in no sense an abstract painter. For him the confrontation with nature was paramount, truth to his sensations the governing criterion.

Monet used perspective, not to lead the eye in a single direction or to control our point of focus, but for opposite ends. The surface of the water is invisible the way a mirror is invisible. Each arm of the reversed Z described by the groups of water lilies leads us in different directions and, in each case, not to a destination or a boundary, but to an implied beyond. The fastest recession among the lilies, the sloping arm of the Z, is countered by the reflections, which turn our sense of near and far on its head, bringing the up of the sky to the down of the picture. In *The River*, nearly forty years earlier, Monet's play with reflection had been firmly framed. In *Morning on the Seine*, reflections had been locked, with great formality, into their source, the trees that caused them. Now neither trees nor water is to be seen directly. We see trees in the water, water in the lilies, the invisible trapped in the invisible. Only the substance of the picture surface stands against it.

Venice, Palazzo Dario, 1908

The following year, the exhibition was again postponed and Monet took a break from the lily pond, going with his wife to Venice. He was delighted by the city and regretted that he had not been there before. He was feeling his age and was disturbed by the first signs of failing eyesight, but he worked with his usual vigor and brought back a number of canvases (see pl. 32) that he went on with at home. Inspired by Venice, he re-engaged with the *Water Lily* pictures and at last showed them, under the collective title *Paysages d'eau* (water landscapes), in May 1909.

Iris, c.1922-26

Water Lilies, c.1925

By 1912, when the Venice pictures were shown, the private world that Monet had made, in which family, garden, and work were in idyllic accord, was threatened at its core. Alice Monet, the center of his establishment, was ill. In 1910 exceptional floods swept through the area, inundating his garden. Madame Monet died the following year. Heartbroken, Monet lost all desire to paint. It was confirmed that he had cataracts in both eyes. His eldest son, Jean, who had married Blanche Hoschedé, also became gravely ill and died in 1914. Blanche moved in to take her mother's place in the household of her stepfather/father-in-law. Gradually the need to paint reasserted itself. Monet's old friend Georges Clemenceau, now a powerful politician, persuaded him to take up his old idea of a decoration based on the motif of water lilies. He began this project in a new studio, large enough for him to work on mural-sized canvases and to maneuver them so that they surrounded him in a continuous array (see fig. 17). He had embarked on an enterprise that was not to end until his death.

The war started in August 1914. Monet's second son, Michel, and his stepson Jean Pierre Hoschedé went off to fight. The horrors of the conflict, the most terrible war that the world had ever known, were not distant: there were times when the front line was less than forty miles from Giverny. In 1917 Clemenceau became prime minister and led the French war effort to the end. But he never lost contact with the work going on in Giverny and, a few days after the armistice was signed, in November 1918, he found time to visit Monet with Geffroy and urged the artist to give the unfinished decorations to the French nation.

By now Monet had been working on the motif of the pool for twenty years. The distinction between work out of doors and in the studio, between observation and memory had become meaningless. The studio and the pool were only minutes apart. He had heavy easels installed by the pool, so that he could work on quite large canvases (see pls. 33 and 34) in the open air. *Iris* (pl. 33), for example, is about six feet square. He was no longer concerned with painting what he saw, in the sense that had determined the scale of his earlier paintings. Now he was looking at fragments, close up, their scale transformed by his large brushes and his way of thinking about the canvas, not as a window but as a decorative surface imagined almost as the surface of the pool itself. And it is this imaginative identification that carried him across the even larger canvases waiting for him indoors, surfaces that

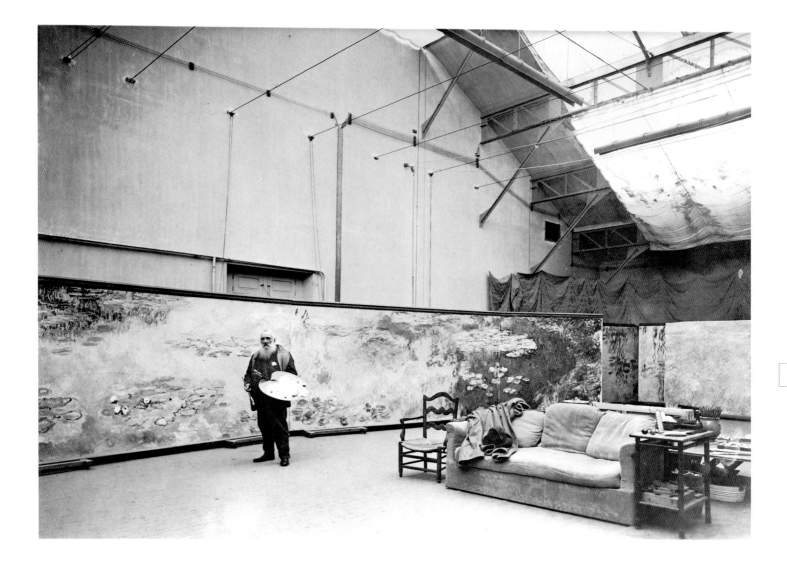

would end up in runs of up to fifty feet long on the walls of the Orangerie in Paris.

The banks of the lily pond were planted with iris and agapanthus and clumps of bamboo. A trellis added to the Japanese bridge was now heavy with wisteria. Monet's ideas for the decorations had included the possibility of some sort of framing of flowers on the bank or hanging down from above. He had contemplated an extensive frieze of wisteria. In the murals at the Orangerie, it is the trunks and foliage of willow trees that serve this framing purpose. Clearly there was a certain contradiction between the unbounded openness of his vision of the pond

17. Claude Monet in the studio constructed for the *Water Lily* decorations, c. 1923.

and this desire to close things off. In *Iris*, one of a number of studies that he made as he explored this contradiction, there is no more attempt to locate the iris than there is to define the surface of the pond beyond them. The flowers seem to burst up toward us from a field of intense ultramarine shot with green and orange whose origin we do not know. Monet did not explain: he did not account for what he saw but rather remade things in his broad brush strokes, his agitated slashes of saturated color, pushing and groping his way across a surface that in the end must speak for itself. This canvas is one of many that lay forgotten in his studio after his death; and, given its lack of resolution, it is hard to imagine that Monet would ever have exhibited it.

Again and again, Monet declared that the task was beyond him, yet the impulse to paint grew stronger than ever. He painted as if he could never stop, continually making fresh starts, his revisions revealing an energy and determination that would have been remarkable in a man half his age. By the time that he had made his promise to Clemenceau, he could no longer trust his color vision, yet he continued to paint, sometimes relying only on the placement of his colors on the palette. In 1922 he signed an agreement with the government to deliver the decorations in two years. He had hoped that they would be housed in a specially built museum designed to meet his conception of an all-enveloping circular space, but in the end he accepted a compromise at the Orangerie. The next year, operations on his eyes left him with new color distortions to adjust to. As he had always done, he continued to fight with circumstances: with outside interference, with the terms of his contract with France, with his own physical limitations, with the impossible challenges that his love for the visible world threw against him day after day—challenges that he could neither ignore nor overcome. At last, two years after the deadline for the completion of the murals had passed, sickness overcame him. He died in December 1926. The *Water Lily* decorations were installed on the walls of the Orangerie the following year.

Monet and Chicago

Monet's fortune was made in America. Today it is difficult fully to appreciate the range and depth of his achievement except by visiting the great public collections in this country. Among these, Chicago's stands very high. In the era of the great capitalist fortunes, when private collections were being put together at an astonishing rate, there were individuals who were prepared to look at new and independent art with an open mind and who recognized in it an adventurousness that matched their own. During the 1860s and 1870s, these people were buying Barbizon

School paintings, by Corot, Millet, and their colleagues. The Barbizon School had been Durand-Ruel's stock in trade until, after 1870, he became interested in the younger generation and in Monet and Renoir in particular. The dealer had tested American waters with a show of Impressionist paintings in Boston in 1883. Of the three works by Monet in this exhibition, one ended up in Chicago: *The Artist's House at Argenteuil*. A few years later, Durand-Ruel found himself under extreme financial pressure, and he decided to gamble everything on the American market. He mounted a major Impressionist exhibition in New York in 1886; it was dominated by forty-eight Monets. In connection with this event, Monet wrote to Durand-Ruel about a recently completed picture that he would "regret to see . . . sent to the land of the Yankees." He did not like his paintings going abroad, but he loved the rewards.

Many of Monet's most ardent defenders were American artists and writers—Mary Cassatt, Desmond Fitzgerald, Lilla Cabot Perry, Theodore Robinson—all of whom played important parts in explaining Monet's work and creating an audience for it. The first American collector of Monet was Louisine Elder, the future Mrs. Horace Havemeyer and a close friend of Cassatt. She acquired a Monet as early as 1875. During the next decade, a number of collectors were buying the new art out of Paris, and Durand-Ruel and soon his rival firm, Boussod & Valadon, were established in New York.

By 1890 Monet's paintings had proved themselves in the American art market and were changing hands at ever-increasing prices. It is at this point that Mrs. Potter Palmer entered the field. Bertha Honoré Palmer (1849–1918) was in every way an extraordinary woman. Her husband made a fortune in real estate and hotels and was involved in developing the city after the Chicago Fire of 1871. His wife was a superb consort in his political and social affairs and earned the sobriquet "the Queen of Chicago." A big-hearted philanthropist, she opened her house for weeks at the time of the Chicago Fire, feeding and sheltering the homeless. She played an important role in the World's Columbian Exposition of 1893, for which she served as President of the Board of Lady Managers and as a driving force behind the epoch-making contribution that women made to that event. She became a figure in society in New York, Paris, and London.

Her interest in collecting contemporary art began during the mid-1880s, when a family mansion was being built and furnished on Lake Shore Drive. The Palmers' first acquisitions were of works by American painters. By the end of the decade, Mrs. Palmer turned her attention to French painting, which she began to buy

at a furious rate—acquiring art by Corot, Degas, Delacroix, Manet, Millet, Monet, Renoir, Sisley, and others. A visitor to Monet's *Wheatstacks* exhibition in 1891, she immediately got the point, becoming the first collector to understand how the separate pictures from the series enhanced one another. She bought nine *Wheatstacks* and, subsequently, multiple works from Monet's later series: the *Poplars*, the *Rouen Cathedrals*, and the *Mornings on the Seine*. She sold as well as bought works, playing a major role in escalating Monet's prices in America. Within three years of buying the *Wheatstacks*, she had sold three of them, one to her friend Mrs. Havemeyer.

The rewards of Mrs. Palmer's insight and enterprise are felt by any visitor who comes to the Art Institute looking for works by Monet. The six Chicago *Wheatstacks*, three of which once belonged to her, provide a unique opportunity to experience something of the serial effect of these works. Other Chicago collectors of Mrs. Palmer's generation contributed to rich Monet holdings. Among them were Mr. and Mrs. Lewis Larned Coburn, who also collected works by Monet's artistic heirs, the Post-Impressionists; and Mr. and Mrs. Martin A. Ryerson, whose important 1933 bequest to the Art Institute included masterpieces in all media from many historical periods. Ryerson, a founding trustee of the Art Institute, visited Monet at Giverny in 1920, hoping to purchase for Chicago the *Water Lilies* murals now permanently installed in the Orangerie in Paris. Thanks to these and other donors, The Art Institute of Chicago boasts an extensive and outstanding group of works by one of the greatest masters of the early modern period, Claude Monet.

Plates

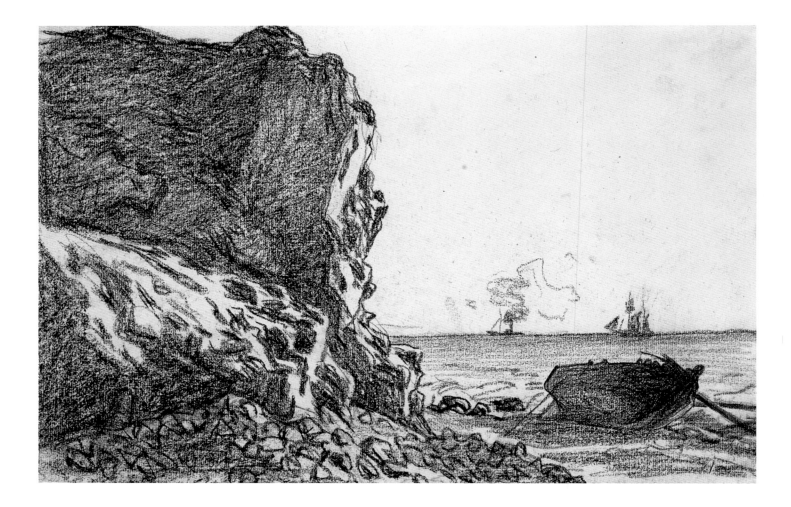

1. Cliffs and Sea, Sainte-Adresse

c. 1865

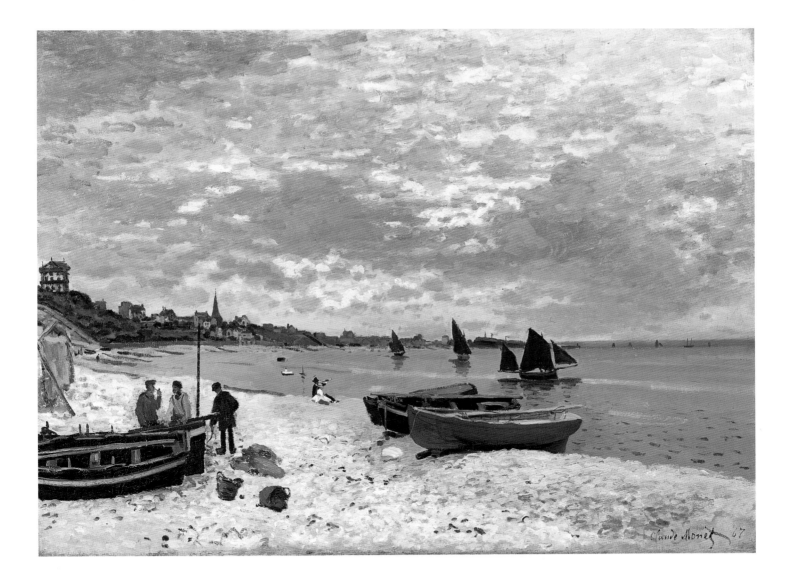

2. The Beach at Sainte-Adresse

1867

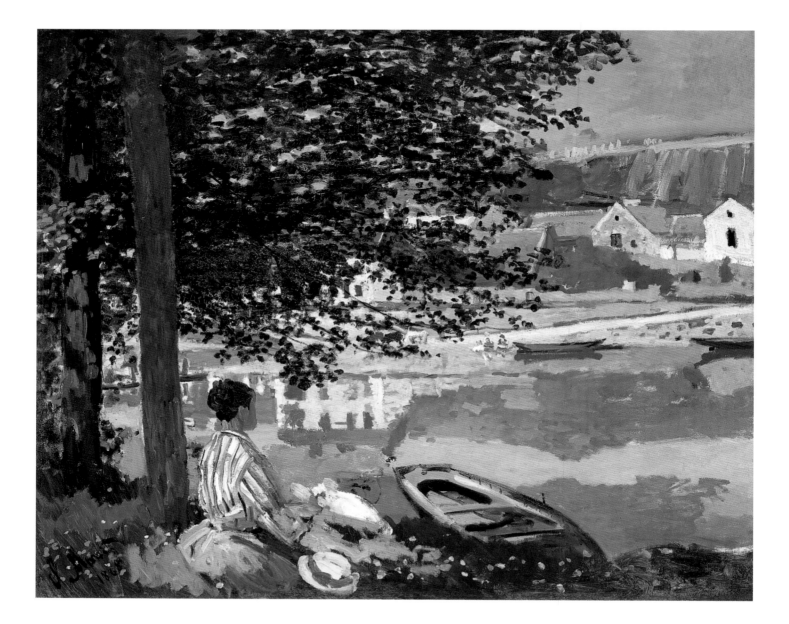

3. On the Bank of the Seine, Bennecourt (The River)

1868

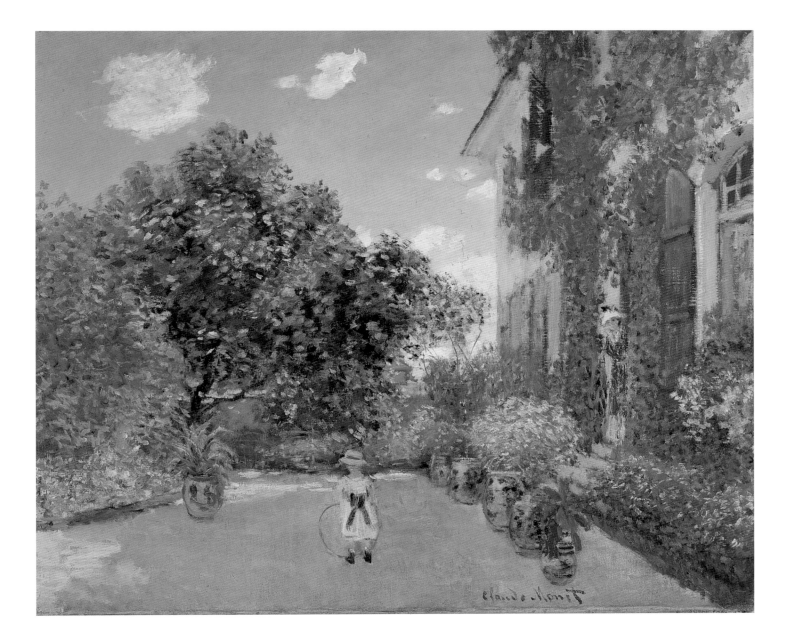

4. The Artist's House at Argenteuil
1873

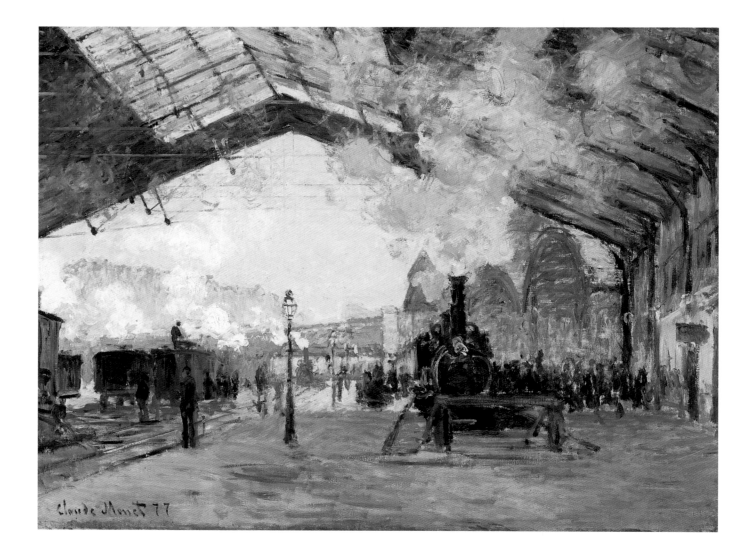

5. Arrival of the Normandy Train, Saint-Lazare Station

1877

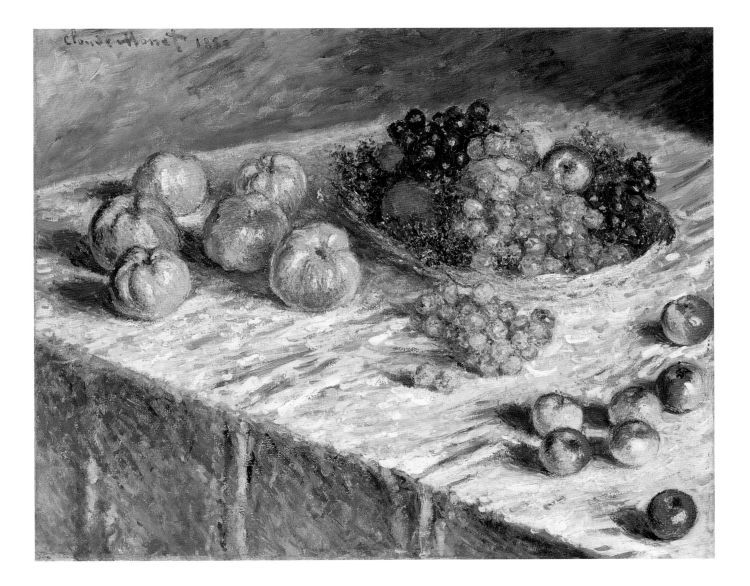

6. Still Life with Apples and Grapes

1880

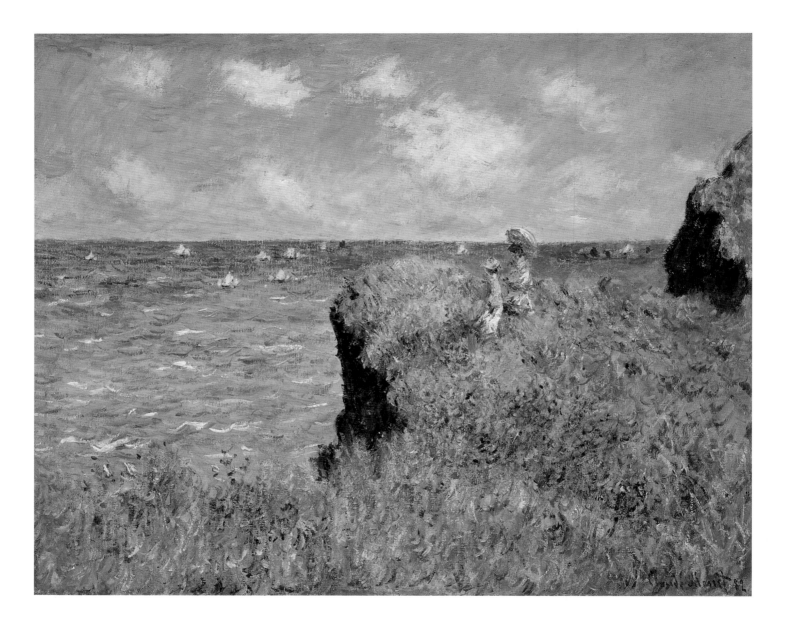

7. Cliff Walk at Pourville

1882

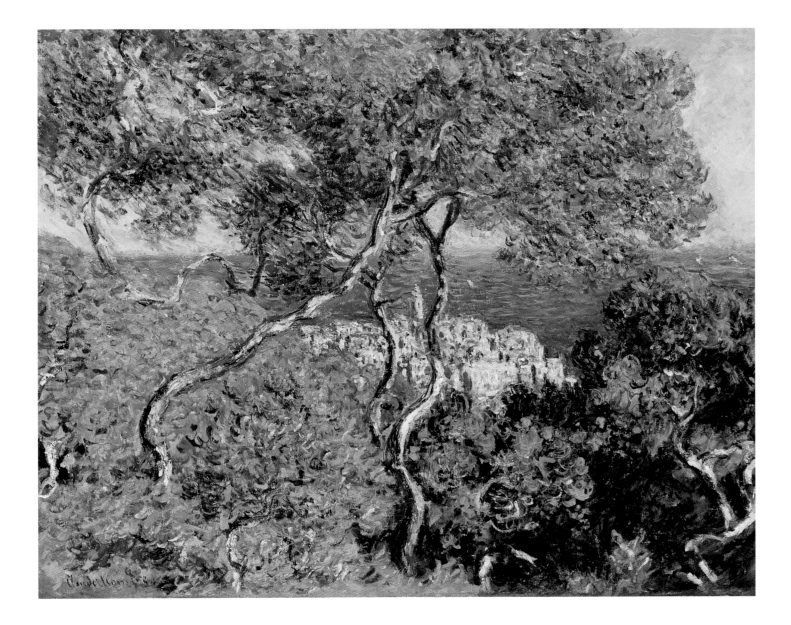

8. Bordighera

1884

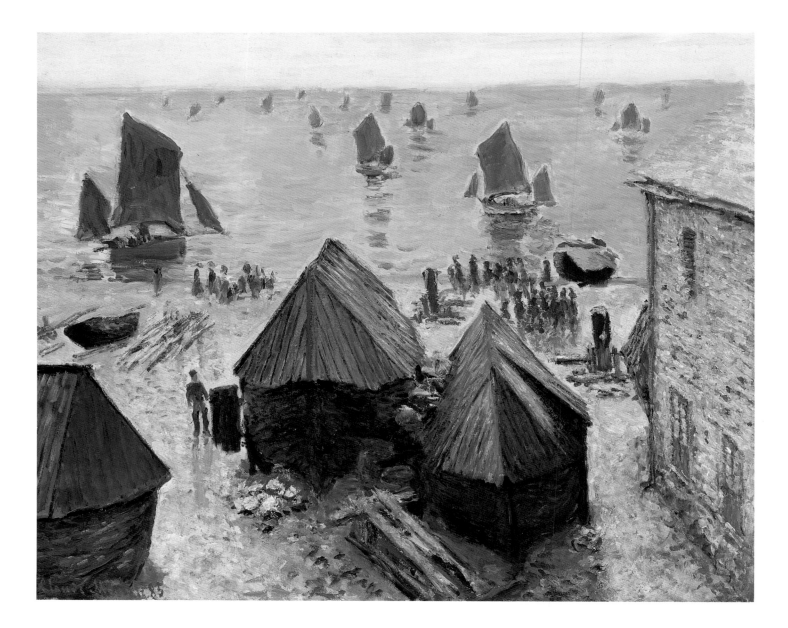

9. The Departure of the Boats, Etretat

1885

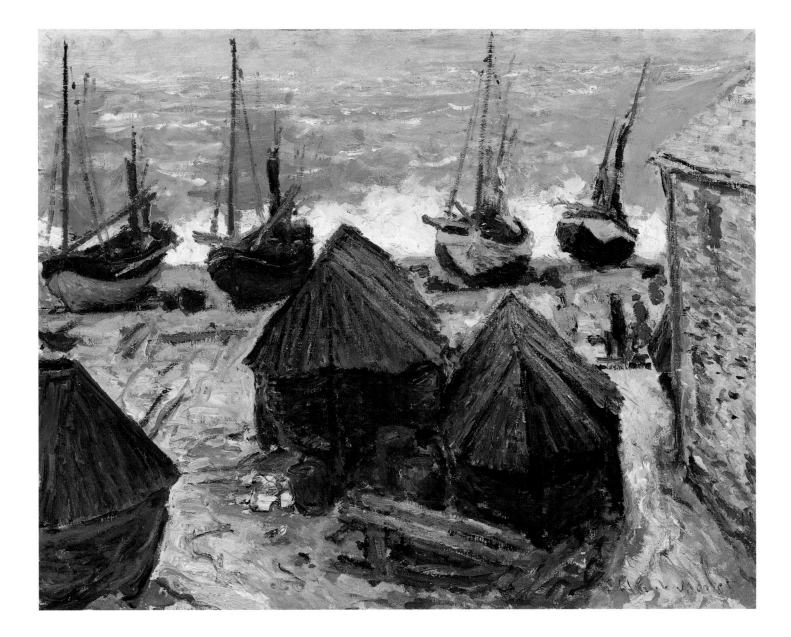

10. Boats in Winter Quarters, Etretat

1885

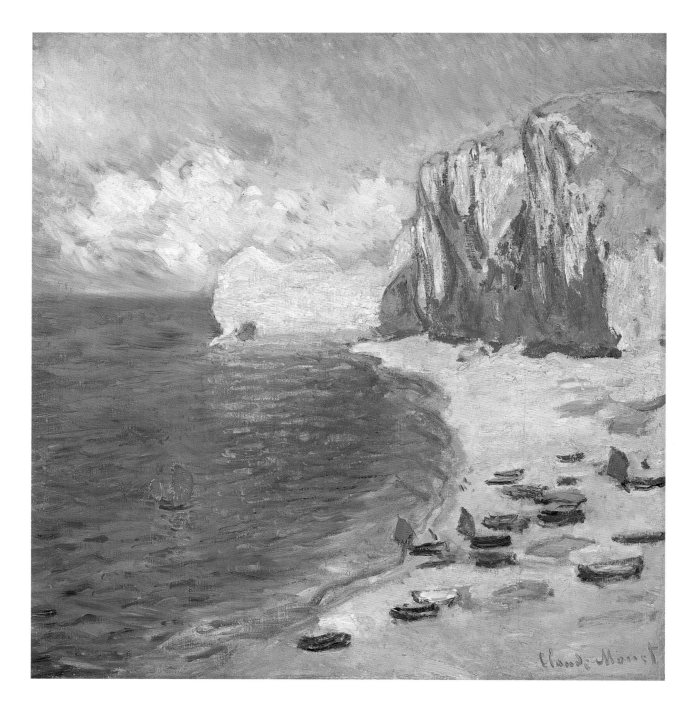

11. Etretat: The Beach and the Eastern Rock Arch

1885

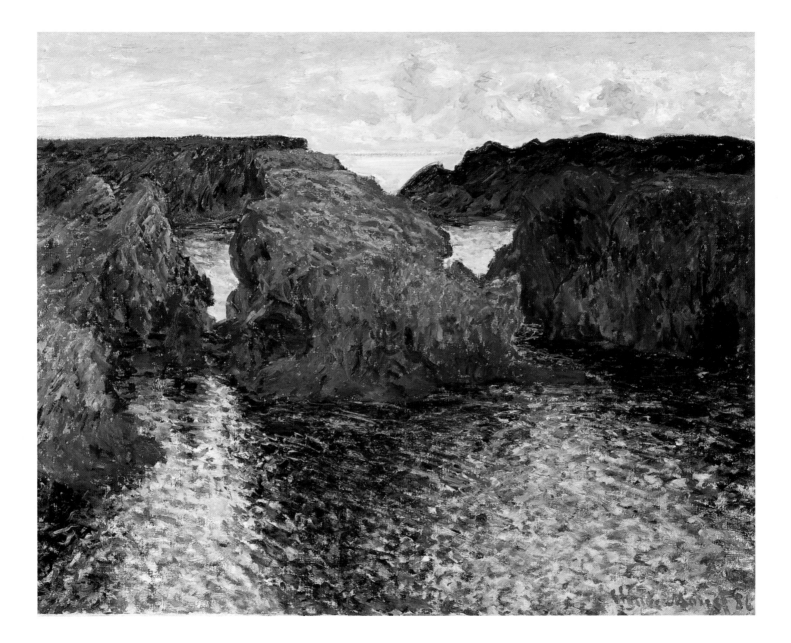

12. Rocks at Belle-Ile

1886

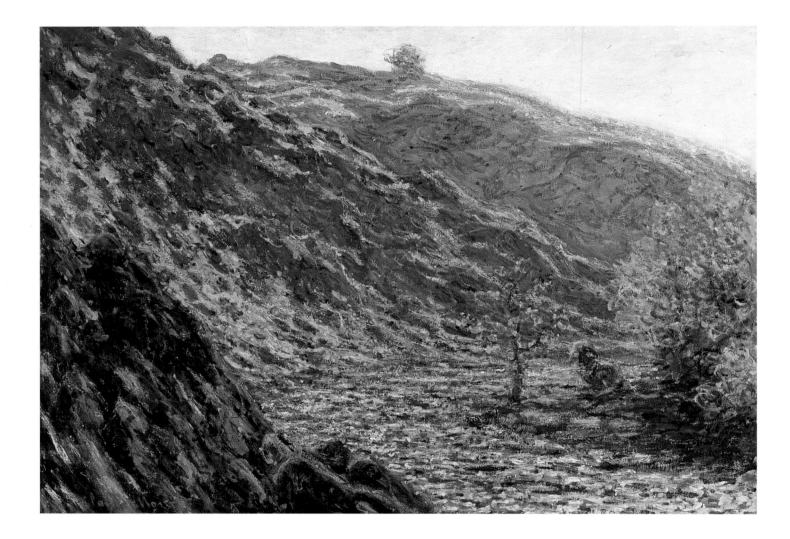

13. The Petite Creuse River

1889

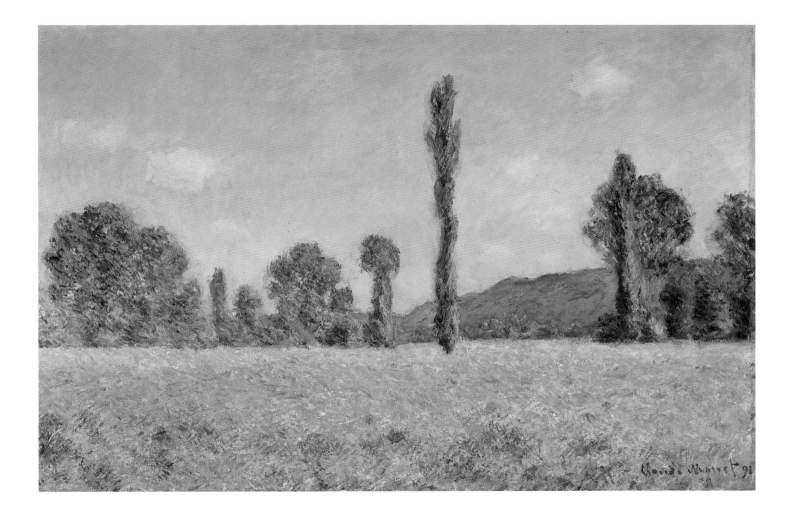

14. Poppy Field (Giverny)

1890-91

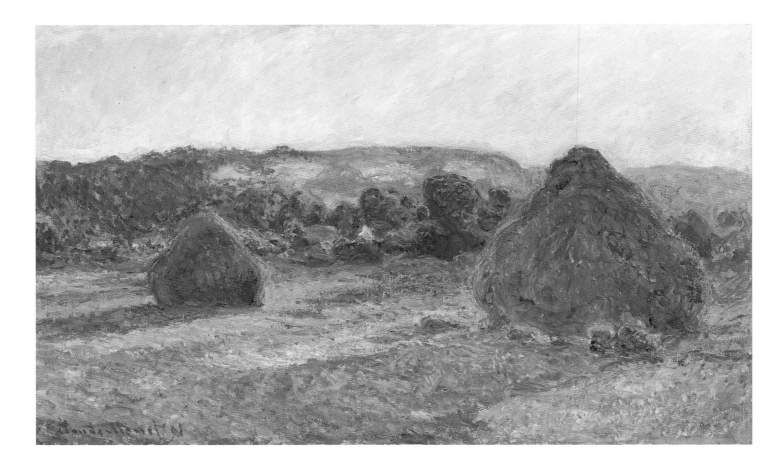

15. Wheatstacks (End of Summer)

1890-91

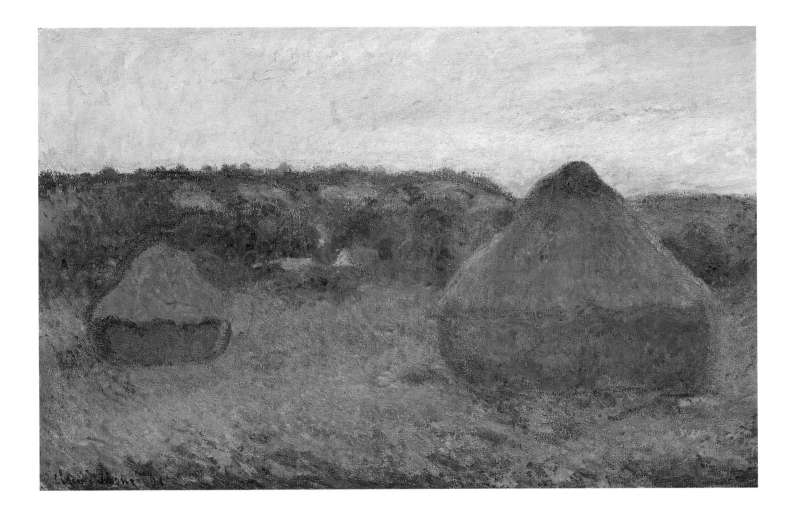

16. Wheatstacks

1890-91

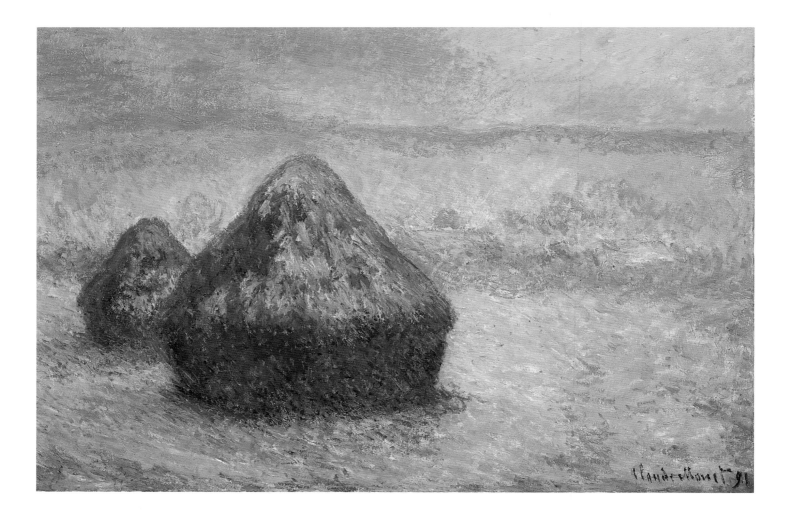

17. Wheatstacks (Sunset, Snow Effect)

1890-91

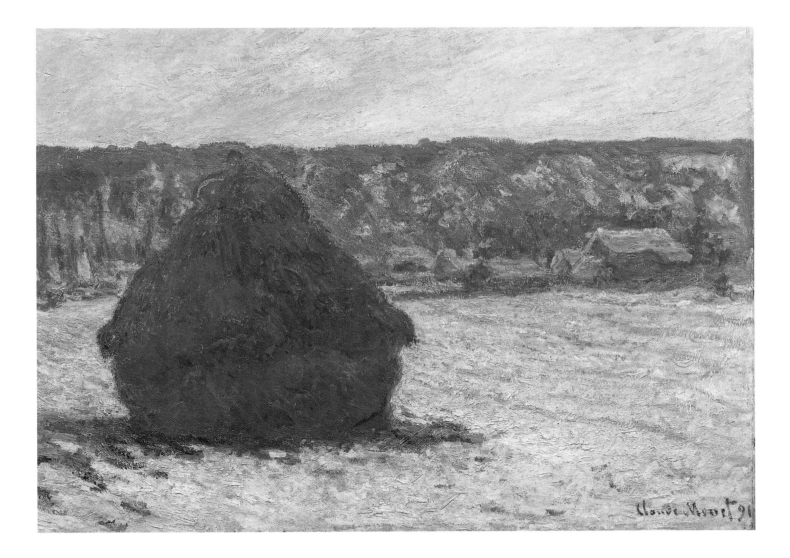

18. Wheatstack (Snow Effect, Overcast Day)

1890-91

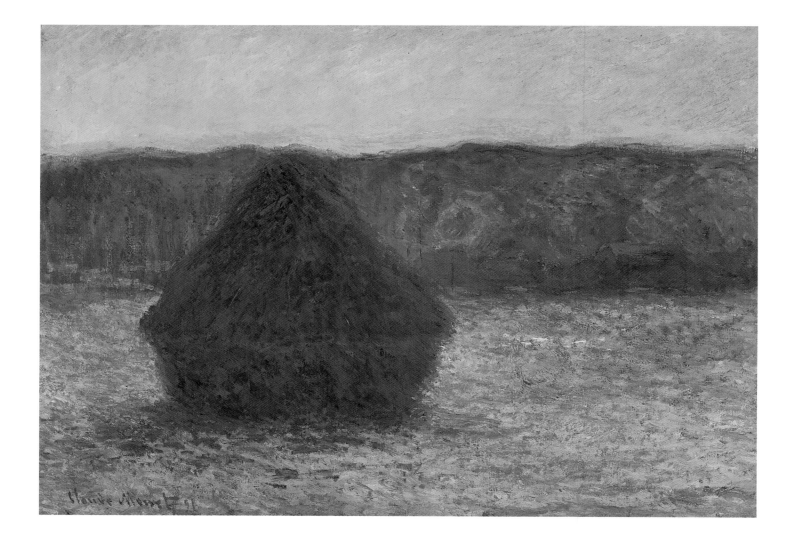

19. Wheatstack (Thaw, Sunset)

1890-91

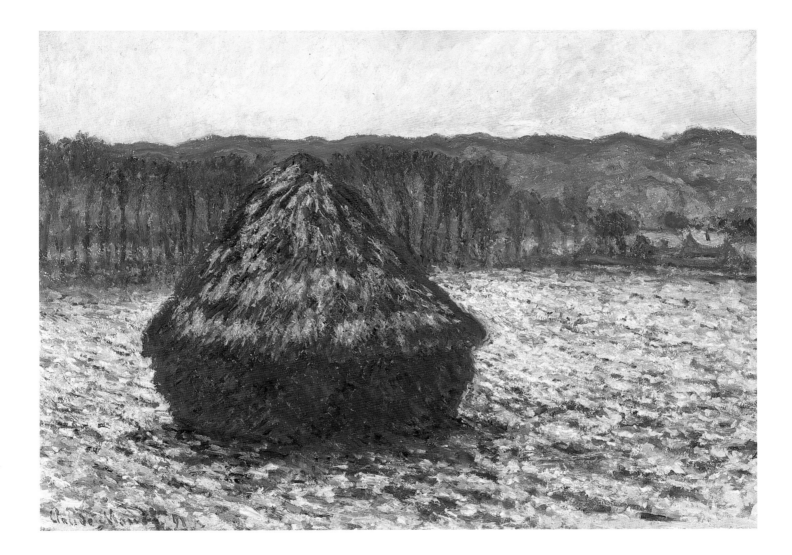

20. Wheatstack

1890-91

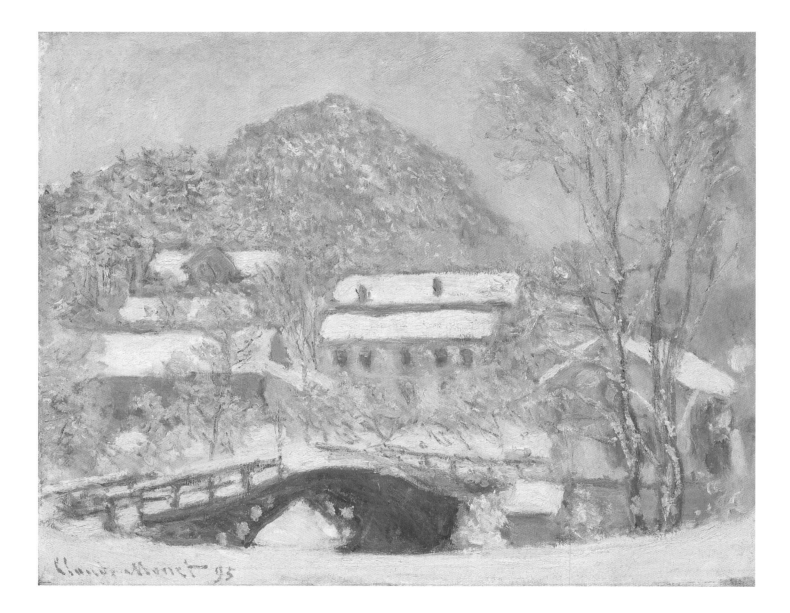

21. Sandvika, Norway

1895

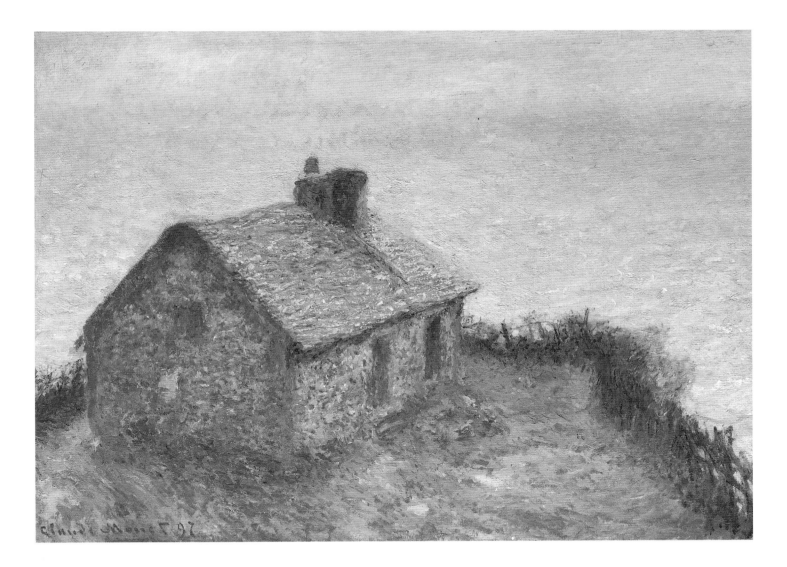

22. Customs House at Varengeville

1897

23. Morning on the Seine, Giverny

1897

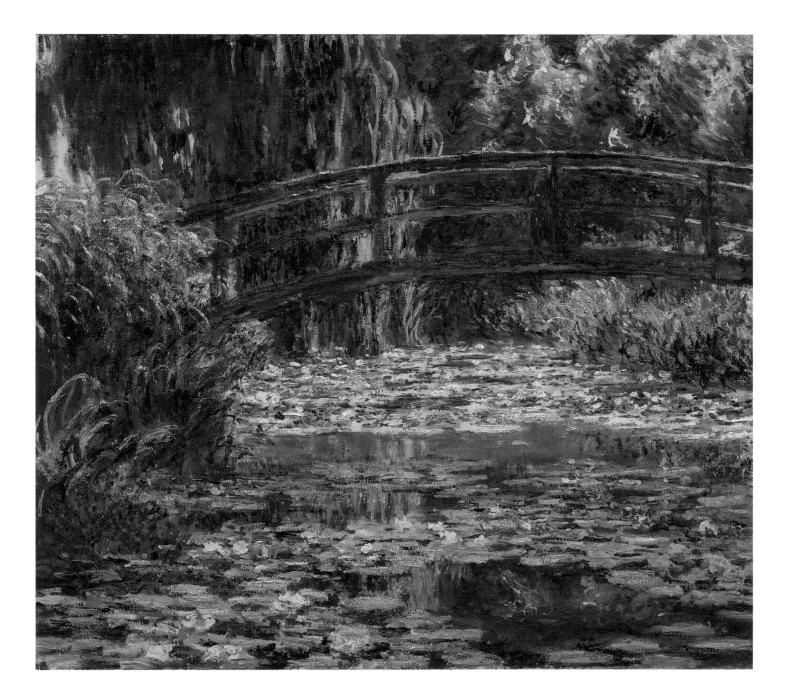

24. Water Lily Garden (The Japanese Bridge)
1900

25. Vétheuil

1901

26. *Vétheuil*

1901

27. Waterloo Bridge, London, Gray Weather

1900

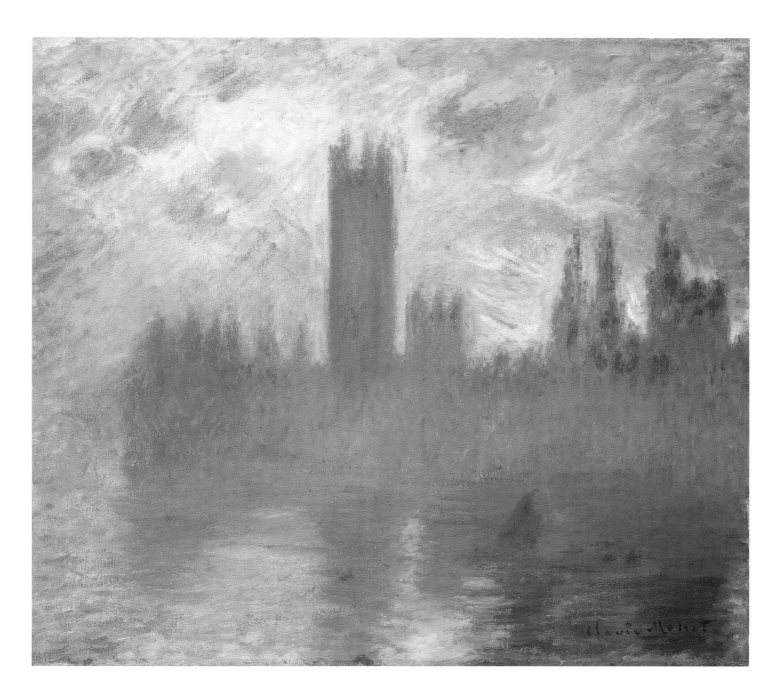

28. Houses of Parliament, London

1900–1901

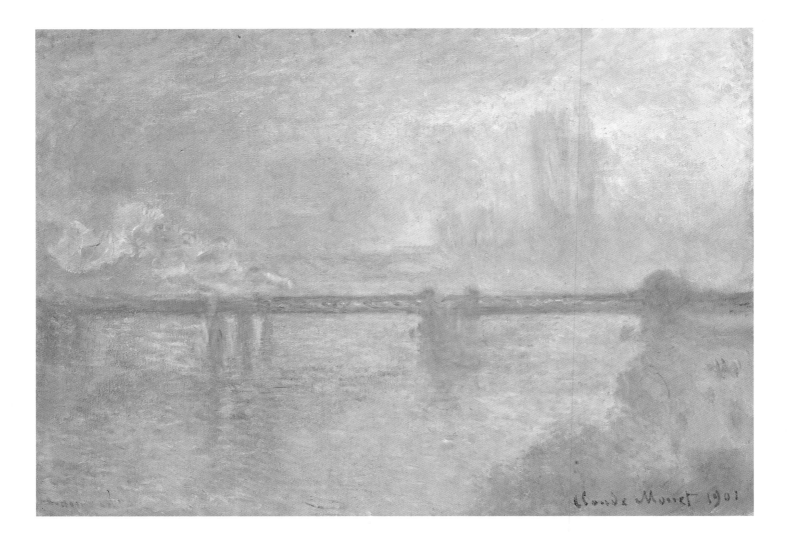

29. Charing Cross Bridge, London

1901

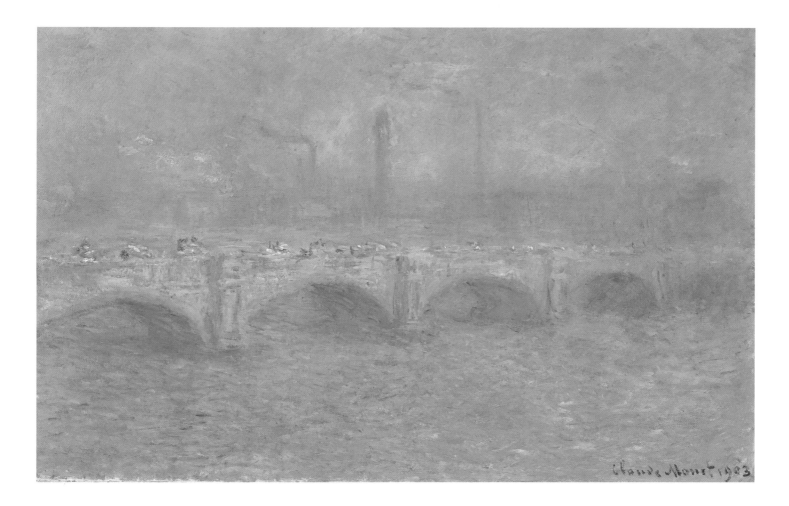

30. Waterloo Bridge, London, Sunlight Effect

1903

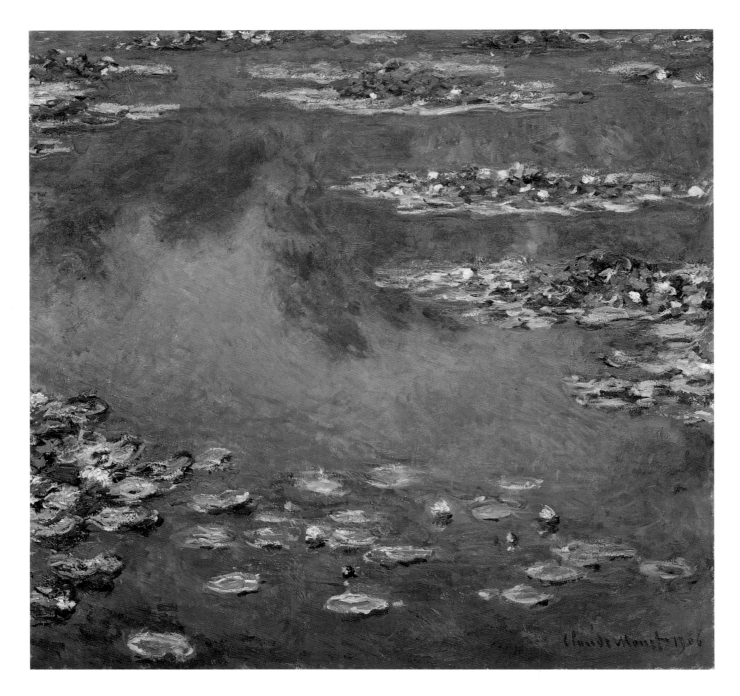

31. Water Lilies

1906

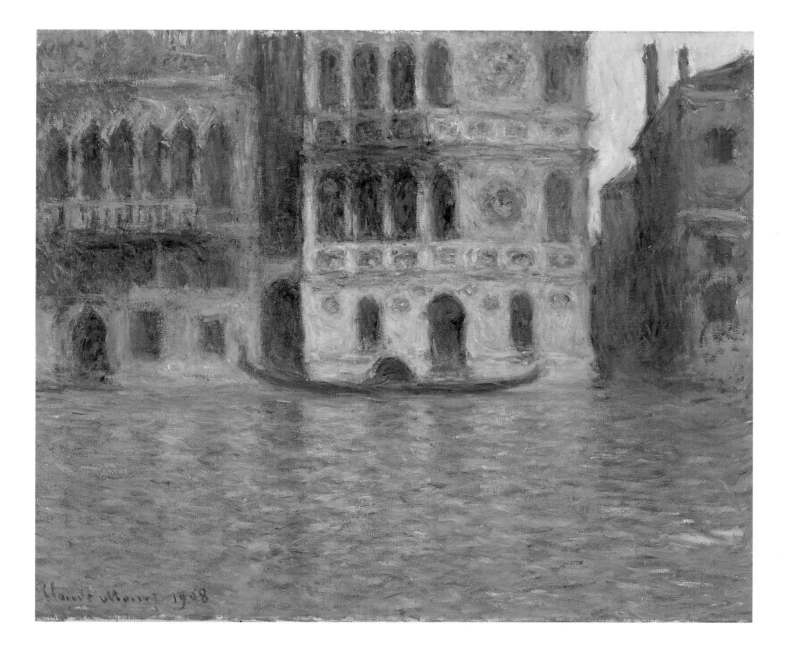

32. Venice, Palazzo Dario

1908

33. Iris

c. 1922-26

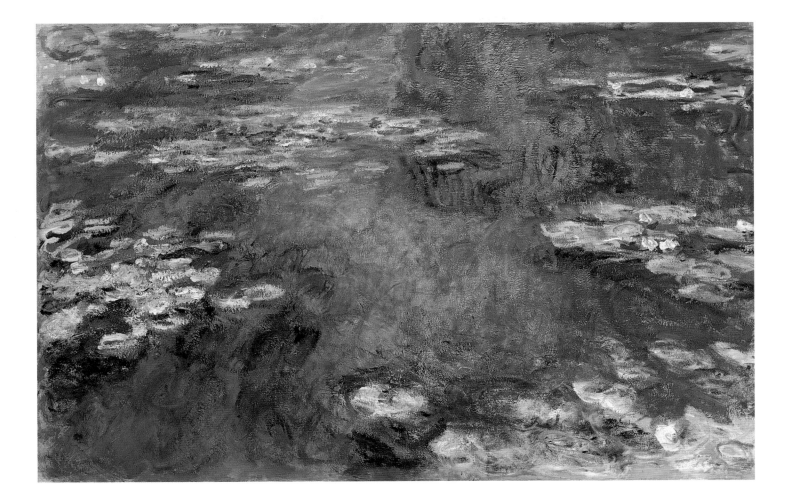

34. Water Lilies

c. 1925

Checklist

All works are oil on canvas, unless otherwise noted.

1. *Cliffs and Sea, Sainte-Adresse*
 c. 1865
 Black chalk on off-white laid paper,
 20.5 x 31.4 cm
 Clarence Buckingham Collection, 1987.56
 Ill. p. 72

2. *The Beach at Sainte-Adresse*
 1867
 75.8 x 102.5 cm
 Mr. and Mrs. Lewis Larned Coburn Memorial
 Collection, 1933.439
 Ill. p. 73

3. *On the Bank of the Seine, Bennecourt (The River)*
 1868
 81.5 x 100.7 cm
 Potter Palmer Collection, 1922.427
 Ill. p. 74, detail p. 15

4. *The Artist's House at Argenteuil*
 1873
 60.2 x 73.3 cm
 Mr. and Mrs. Martin A. Ryerson Collection,
 1933.1153
 Ill. p. 75, detail p. 19

5. *Arrival of the Normandy Train,*
 Saint-Lazare Station
 1877
 59.6 x 80.2 cm
 Mr. and Mrs. Martin A. Ryerson Collection,
 1933.1158
 Ill. p. 76

6. *Still Life with Apples and Grapes*
 1880
 66.2 x 82.3 cm
 Mr. and Mrs. Martin A. Ryerson Collection,
 1933.1152
 Ill. p. 77, detail p. 27

7. *Cliff Walk at Pourville*
 1882
 65 x 81 cm
 Mr. and Mrs. Lewis Larned Coburn Memorial
 Collection, 1933.443
 Ill. p. 78, detail p. 7

8. *Bordighera*
 1884
 64.8 x 81.3 cm
 Potter Palmer Collection, 1922.426
 Ill. p. 79, detail p. 33

9. *The Departure of the Boats, Etretat*
 1885
 74 x 92.7 cm
 Potter Palmer Collection, 1922.428
 Ill. p. 80

10. *Boats in Winter Quarters, Etretat*
 1885
 65 x 81 cm
 Charles H. and Mary F. S. Worcester
 Collection, 1947.95
 Ill. p. 81

11. *Etretat: The Beach and the Eastern Rock Arch*
 1885
 69.3 x 66.1 cm
 Gift of Mrs. John H. (Anne R.) Winterbotham
 in memory of John H. Winterbotham; Joseph
 Winterbotham Collection, 1964.204
 Ill. p. 82

12. *Rocks at Belle-Ile*
 1886
 65 x 81 cm
 Gift of Mr. and Mrs. Chauncey B. Borland,
 1964.210
 Ill. p. 83

13. *The Petite Creuse River*
 1889
 65.9 x 93.1 cm
 Potter Palmer Collection, 1922.432
 Ill. p. 84, detail p. 41

14. *Poppy Field (Giverny)*
1890–91
61.2 x 93.1 cm
Mr. and Mrs. W. W. Kimball Collection,
1922.4465
Ill. p. 85

15. *Wheatstacks (End of Summer)*
1890–91
60 x 100 cm
Arthur M. Wood in memory of Pauline Palmer
Wood, 1985.1103
Ill. p. 86

16. *Wheatstacks*
1890–91
65.8 x 101 cm
Mr. and Mrs. Lewis Larned Coburn Memorial
Collection, 1933.444
Ill. p. 87

17. *Wheatstacks (Sunset, Snow Effect)*
1890–91
65.3 x 100.4 cm
Potter Palmer Collection, 1922.431
Ill. p. 88, detail p. 47

18. *Wheatstack (Snow Effect, Overcast Day)*
1890–91
66 x 93 cm
Mr. and Mrs. Martin A. Ryerson Collection,
1933.1155
Ill. p. 89

19. *Wheatstack (Thaw, Sunset)*
1890–91
64.9 x 92.3 cm
Gift of Mr. and Mrs. Daniel C. Searle,
1983.166
Ill. p. 90

20. *Wheatstack*
1890–91
65.6 x 92 cm
Restricted gift of the Searle Family Trust;
Major Acquisitions Centennial Endowment;
through prior acquisitions of the Mr. and Mrs.
Martin A. Ryerson and Potter Palmer
Collections; through prior bequest of Jerome
Friedman, 1983.29
Ill. p. 91

21. *Sandvika, Norway*
1895
73.4 x 92.5 cm
Gift of Bruce Borland, 1961.790
Ill. p. 92

22. *Customs House at Varengeville*
1897
65.6 x 92.8 cm
Mr. and Mrs. Martin A. Ryerson Collection,
1933.1149
Ill. p. 93

23. *Morning on the Seine, Giverny*
1897
89.9 x 92.7 cm
Mr. and Mrs. Martin A. Ryerson Collection,
1933.1156
Ill. p. 94

24. *Water Lily Garden (The Japanese Bridge)*
1900
89.9 x 100.1 cm
Mr. and Mrs. Lewis Larned Coburn
Memorial Collection, 1933.441
Ill. p. 95

25. *Vétheuil*
1901
89 x 92 cm
Mr. and Mrs. Martin A. Ryerson Collection,
1933.1161
Ill. p. 96

26. *Vétheuil*
1901
90 x 93 cm
Mr. and Mrs. Lewis Larned Coburn
Memorial Collection, 1933.447
Ill. p. 97

27. *Waterloo Bridge, London, Gray Weather*
1900
65.4 x 92.4 cm
Gift of Mrs. Mortimer B. Harris, 1984.1173
Ill. p. 98, detail p. 59

28. *Houses of Parliament, London*
1900–1901
81 x 92 cm
Mr. and Mrs. Martin A. Ryerson Collection,
1933.1164
Ill. p. 99

29. *Charing Cross Bridge, London*
1901
63.6 x 91.5 cm
The Art Institute of Chicago, Mr. and Mrs.
Martin A. Ryerson Collection, 1933.1150
Ill. p. 100

30. *Waterloo Bridge, London, Sunlight Effect*
1903
65.7 x 101 cm
Mr. and Mrs. Martin A. Ryerson Collection,
1933.1163
Ill. p. 101

31. *Water Lilies*
1906
87.6 x 92.7 cm
Mr. and Mrs. Martin A. Ryerson Collection,
1933.1157
Ill. p. 102, detail p. 59

32. *Venice, Palazzo Dario*
1908
64.8 x 80.7 cm
Mr. and Mrs. Lewis Larned Coburn
Memorial Collection, 1933.446
Ill. p. 103

33. *Iris*
c. 1922–26
200 x 201 cm
Purchase Fund, 1956.1202
Ill. p. 104

34. *Water Lilies*
c. 1925
130.2 x 201.9 cm
Gift of Mrs. Harvey Kaplan, 1982.825
Ill. p. 105

Selected Bibliography

Gordon, Robert, and Andrew Forge. *Monet*.
New York: Harry N. Abrams, Inc., 1983.

Herbert, Robert. *Impressionism: Art, Leisure, and Parisian Society*. New Haven and London: Yale University Press, 1988.

House, John. *Monet: Nature into Art*. New Haven and London: Yale University Press, 1986.

Joyes, Claire, Robert Gordon, Jean-Marie Toulgouat, and Andrew Forge. *Monet at Giverny*. New York: Two Continents, 1976.

Rewald, John. *The History of Impressionism*. 4th ed. New York: Museum of Modern Art, 1973.

Spate, Virginia. *The Colour of Time: Claude Monet*. London: Thames and Hudson, 1992.

Stuckey, Charles F. *Claude Monet: 1840–1926*. Chicago and London: The Art Institute of Chicago and Thames and Hudson, 1995.

Tucker, Paul Hayes. *Monet at Argenteuil*. New Haven and London: Yale University Press, 1982.

Tucker, Paul Hayes. *Monet in the '90s: The Series Paintings*. New Haven and London: Yale University Press, 1989.